IMAGES
of America

MILWAUKEE'S
OLD SOUTH SIDE

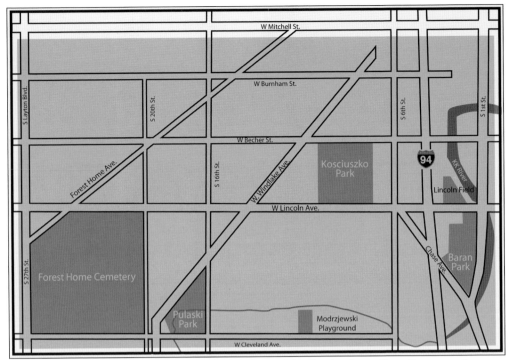

The boundaries for Milwaukee's Old South Side used for this book are First Street on the east, Twenty-seventh Street on the west, Maple Street on the north (one block south of Mitchell Street), and Cleveland Avenue on the south. Some sources expand these boundaries farther north, south, and west. (Courtesy of Urban Anthropology.)

ON THE COVER: For over 100 years, the Poles dominated the Old South Side. At a time when ethnic groups were under pressure to assimilate to an Anglo American standard, it was common to see public displays of ethnicity modified by discernible displays of American flags. The backdrop for this image is Lincoln Avenue with its curved and angular parapets extending above roofs of commercial buildings—an architectural feature the Poles brought with them from their homeland. (Courtesy of Kwasniewski Photographs, UWM Libraries, kw000923.)

IMAGES
of America

MILWAUKEE'S
OLD SOUTH SIDE

Jill Florence Lackey and Rick Petrie

ARCADIA
PUBLISHING

Published by Arcadia Publishing
Charleston, South Carolina

Printed in the United States of America

Library of Congress Control Number: 2012949272

For all general information, please contact Arcadia Publishing:
Telephone 843-853-2070
Fax 843-853-0044
E-mail sales@arcadiapublishing.com
For customer service and orders:
Toll-Free 1-888-313-2665

Visit us on the Internet at www.arcadiapublishing.com

This book is dedicated to the diverse residents of the Old South Side, past and present, who made the decision to live, work, worship, and celebrate together in relative harmony.

CONTENTS

Acknowledgments 6

Introduction 7

1. Ethnicity and the Old South Side 9

2. Celebrations 21

3. Sports 33

4. Arts 43

5. Institutions 53

6. Green Spaces 73

7. Architecture and Monuments 81

8. Ethnic Markers 89

9. Businesses over the Generations 93

10. Specialties and Restaurants 113

Index 126

About Urban Anthropology 127

ACKNOWLEDGMENTS

The authors wish to give special thanks to the Roman B.J. Kwasniewski Photographs collection in the Archives Department of the University of Wisconsin-Milwaukee Libraries for their images. Special appreciation is also extended to Barbara Nelson for her zeal in collecting hard-to-find photographs and Susan Mikos for extensive review of captions. The authors would also like to thank the following sources for permission to use their photographs: the Rozga family, the Garcia-Guerrero family, the Hanoski family, the Mazo family, George Baker, Ace Boxing Club, the Lackey family, the Felix Mantilla Little League/UCC, the Hodges family, the Figueroa family, the Porter family, Hoard Historical Museum, Alexandra Trumbull-Holper, Kathrin Fiedler Schmid, the Basilica of St. Josaphat Foundation, Urban Anthropology Inc., the Milwaukee Public Library, the Milwaukee County Historical Society, the Wisconsin State Historical Society, Margaret Rozga Groppi, St. Hyacinth School, Kosciuszko Montessori School, and St. Josaphat Parish School.

The Roman B.J. Kwasniewski Photographs collection, in the Archives Department, University of Wisconsin-Milwaukee Libraries, provides the majority of images in this publication. The Kwasniewski collection is comprised of over 35,000 images dating from 1907 to 1947 and is a rich visual record of community life in Milwaukee's South Side Polish community in the early 20th century. Roman B.J. Kwasniewski lived from 1886 to 1980 and is known for his documentation of Milwaukee's "Polonia" neighborhood. Kwasniewski's Park Studio was located on Lincoln Avenue near Kosciuszko Park. Kwasniewski's studio photographs depict family events such as first communions, graduations, weddings, ordinations, anniversaries, and funerals. Other images are of street scenes; homes; businesses; construction; Polish American organizations, and social events such as birthdays, holidays, "Hard Times" parties, parades, and picnics. The UWM Libraries' Archives Department acquired the Kwasniewski collection in 1979 from the family, with assistance from Polanki, the Polish Women's Cultural Club of Milwaukee. Rep. Walter Kunicki and John Plewa helped secure state funding for processing the collection. Access to the collection is available through the Archives Department, or via www.uwm.edu/libraries.

INTRODUCTION

If one adjective could be used to describe Milwaukee's Old South Side, it would be *ethnic*. The Old South Side was once Milwaukee's largest *Polonia*, or Polish community, living outside of Poland. The Poles began to arrive in large numbers in the 1870s and by the early 20th century had organized federations, social clubs, sports teams, amateur theater, veterans' groups, art clubs, and newspapers. They built miles of homes, businesses, schools, and churches—the crowning achievement being the construction of the Basilica of St. Josaphat.

The Polonia grew up during the age of the "melting pot" where cultural differences were expected to disappear into an Anglo American standard. While the Poles prominently displayed American flags in their homes and businesses, they struggled to retain and express their Polishness. The following story exemplifies the struggle. In 1907, Michal Kruszka, editor of the *Kuryer Polski*, a locally based Polish language newspaper, wrote a letter to the archbishop, S.G. Messmer. In the letter, Kruszka accused the archbishop of trying to destroy the reputation of his Old South Side family through a newspaper he helped organize, the *Nowiny*, another Polish-language paper published in Milwaukee. Kruszka, through the *Kuryer*, had been accusing the archdiocese for years of denying Polish priests the opportunity to advance in the church. Now Kruszka claimed that the archbishop was using the *Nowiny* to discredit him and his family. According to Kruszka, a major strategy was insinuating that the family did not truly value its Polish heritage. One of the accusations Kruszka made was that the *Nowiny* falsely reported that Kruszka's daughter barely spoke Polish, an accusation Kruszka adamantly denied. According to Kruszka, the false information "will cause a social ostracism of her among the Polish people, will ruin her whole future."

The Old South Side remained solidly Polish for over 100 years. But freeway building and the urban renewal programs in the 1950s and 1960s began to change ethnic neighborhoods—even eliminating several. The construction of Interstate 43 removed hundreds of Old South Side homes, leaving the Poles with a housing shortage. Some began to move to southern suburbs, beginning a slow migration of Poles out of the Old South Side. Highway building and the Urban Renewal Administration had a more deleterious effect on the north side of Milwaukee. In the African American neighborhood known as Bronzeville, 8,000 homes were razed. The black community was not yet protected by fair housing legislation and many families had nowhere to go. These developments led to the Fair Housing Marches of 1967. On August 24, NAACP Youth Council members announced a march from Milwaukee's north side to Kosciuszko Park in the heart of the Old South Side, where African Americans had at times been denied housing. The march to Kosciuszko and subsequent passing of a fair housing ordinance, coupled with the out-migration of Poles that had already begun, signaled impending change to the ethnic makeup of the area.

The civil rights movement that captured national attention in the 1960s gradually changed the way Americans looked at ethnic differences. Over the next several decades, the "melting pot" metaphor slowly gave way to the "salad bowl," suggesting that it was now desirable for different ingredients in a population to retain their own flavors. Ethnic diversity was becoming a mark of

distinction. There had always been a few non-Poles living on the Old South Side. Most prominent were American Indian families, who now began to identify themselves proudly. On the Old South Side, the American Indian families were particularly known for their contributions to the local youth organizations, as exemplified through service to the Ace Boxing Club from 1960 into the 21st century.

Despite the Old South Side being a focal point of the Fair Housing Marches, African Americans did not migrate to the area in significant numbers after 1967. The groups that came in large numbers were Latinos, particularly Mexican Americans. A substantial number of Mexicans had lived on Milwaukee's south side since the 1920s, but had stayed just north of the Old South Side. The first known Mexican family moving to the Old South Side purchased a home on Burnham Street in 1956. A few other families followed. But it was not until enough Poles had migrated out of the area in the 1970s that homes were available for sale or rent. The Mexicans proved to be a natural ally of the Poles, as both groups were overwhelmingly Catholic and kept extended family ties. They shared a similar work ethic and tended to take available jobs in factories such as tanneries and foundries. Both were highly entrepreneurial. By the 21st century, almost half the businesses on the Old South Side had Spanish names.

Other ethnic groups moved in. A door-to-door survey conducted by Urban Anthropology Inc. in 2009 found that 110 nations were represented on the Old South Side, making the area one of the most diverse in the state of Wisconsin. The top populations were Mexicans, Poles, and American Indians, in that order. As a way to honor the three largest ethnic groups, local organizations held a festival called Gathering by the Waters to educate Milwaukee residents on the practices and contributions of the three groups. Begun in 2012, the festival is slated to be repeated biannually.

Ethnicity is represented everywhere on the Old South Side—in public art, yard displays, and home and commercial building facades. The Old South Side is the most densely populated area in the city and yet, curiously, is bursting with green space. Three large parks of over 25 acres each, two smaller parks, and a 200-acre landmark cemetery lie within the boundaries of the Old South Side. While Kosciuszko Park, named after Revolutionary hero and civil rights champion Thaddeus Kosciuszko, was never the area's largest park, it has historically been the one where most festivals and celebrations take place.

Two major streets were associated with Milwaukee Poles: Mitchell Street and Lincoln Avenue. While Mitchell Street is on Milwaukee's south side, the authors did not include this in their boundaries of the Old South Side because the area from Mitchell Street north to the center of Milwaukee had a somewhat different cultural history. It had become multiethnic by the early 20th century, which was not the case with the community farther south. Lincoln Avenue was the other "main street." While Mitchell Street housed a number of department stores and large commercial establishments, Lincoln Avenue catered to the mom-and-pop merchants. The frame storefronts were rarely more than 40 feet in width. Most of the facades remain today adorned with curved or angular parapets that were popular in the Prussian Partition of occupied Poland, the area from which most of the immigrant Poles of the Old South Side emigrated. Unlike many commercial streets in urban neighborhoods, Lincoln Avenue rarely has had an empty building or a vacant lot. Diversity is a prominent theme today along the main street and nearly every block has at least one ethnic restaurant. The bustling business district of the Polish years has simply expanded into the bustling business district, serving residents of 110 nations.

One

ETHNICITY AND THE OLD SOUTH SIDE

A major story of the Old South Side has been its movement from a Polonia in the late 1800s to a neighborhood of 110 nations by 2009. The area remained principally Polish into the 1970s during periods when other ethnic neighborhoods had been fractured by the freeway construction and urban renewal programs of the 1950s and 1960s. In 1967, the Old South Side, portrayed as a surviving fortress of white ethnicity, was selected as a destination for the Fair Housing Marches. The marches were organized by African Americans and their supporters on Milwaukee's north side as a means to draw attention to housing discrimination in the city. This historic event, combined with a mounting neighborhood concern for social justice and growing interest in cultural diversity, began to open the doors for ethnic change.

And change did follow. By the 1970s, large groups of Latinos began migrating into the area. Within 20 years, Mexican Americans overtook Poles as the largest ethnic group on the Old South Side. American Indians comprised the third largest population. These three groups and others contributed innovatively to the celebratory, creative, institutional, and commercial life of the area.

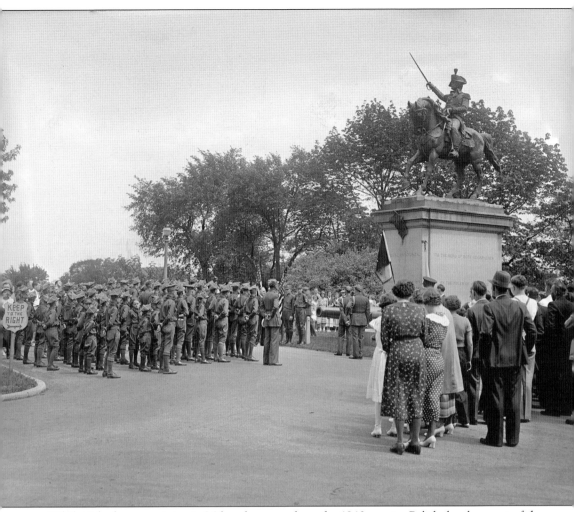

While Poles began arriving in Milwaukee as early as the 1840s, major Polish development of the Old South Side did not occur until after 1870. The Poles settled in three areas of Milwaukee. One settlement was in the Brady Street area on Milwaukee's east side. Another was on the Milwaukee peninsula named Jones Island (which had once been an island). The Jones Island Poles, also known as Kaszubs, were immigrants from the Kaszuby region on the Baltic seacoast. However, the largest group of Poles ended up on Milwaukee's south side. They first settled on the near south side near Mitchell Street and gradually pushed south and west into the area defined in this volume as the Old South Side. For over 100 years, the neighborhood was predominantly Polish with a scattering of Germans, American Indians, and other Europeans moving in and out of the neighborhood during that era. In this c. 1940 photograph, the local Poles gather for a celebration at the monument of Gen. Thaddeus Kosciuszko in Kosciuszko Park. (Courtesy of Kwasniewski Photographs, UWM Libraries, kw000830.)

The Rozgas were cornerstone citizens of the Old South Side. Steven Rozga emigrated from Poland in 1881. He and his wife, Anna, opened a furniture store on Lincoln Avenue. When their best-selling item proved to be caskets, they picked up the cue and opened the Rozga Funeral Home in 1898. Since then, the business has served generations of Milwaukeeans. (Courtesy of the Rozga family.)

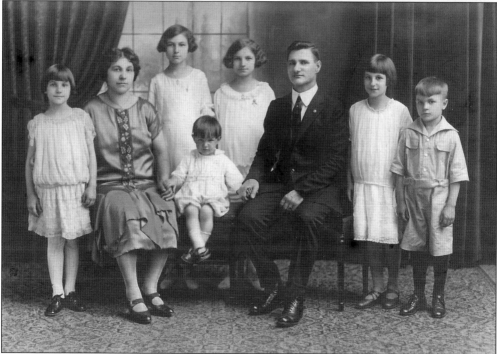

The Rozga couple's son John, also a leader among the early Poles, participated in the family business with his wife, Kate Rozga, and their children (pictured here about 1927). By the mid-1920s, John opened a second funeral home several miles west on Lincoln Avenue that did not survive the Great Depression. He rejoined his father's business in the mid-1930s. (Courtesy of the Rozga family.)

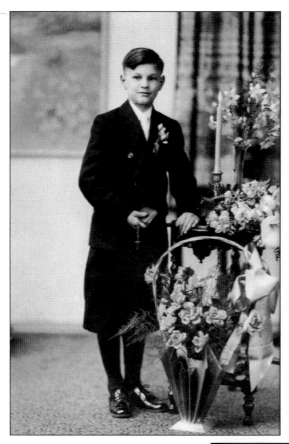

Tom Rozga (pictured here at his first communion about 1930) was the next proprietor of the Rozga Funeral Home. He operated the original Rozga Funeral Home on the Old South Side into the 21st century, living above the business with his family. His son, also named John, took over the business in 2005. (Courtesy of the Rozga family.)

Roman Kwasniewski (1886–1980) chronicled life on the Old South Side with his photographs. A son of Polish immigrants, Kwasniewski established a photography studio and residence on Lincoln Avenue, eventually leaving behind a collection of over 30,000 images, many of which appear in this volume. (Courtesy of Kwasniewski Photographs, UWM Libraries, kw000440.)

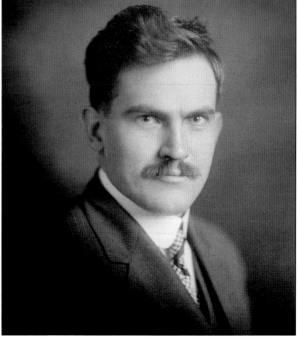

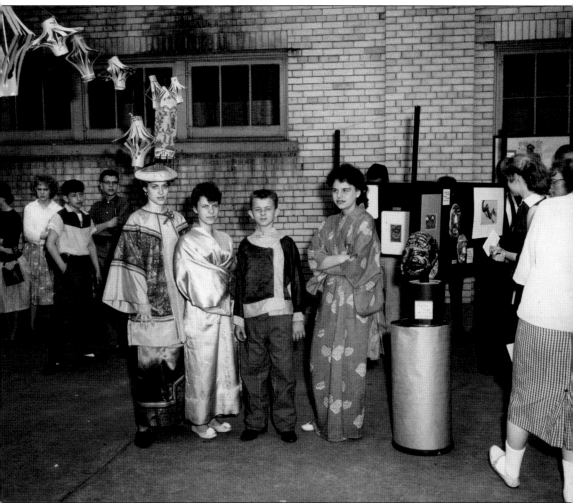

While the Old South Side was predominantly Polish until the 1970s, residents had some interest in diversity. Above, students at local Kosciuszko School dressed up as Asians at one of their folk fairs, about 1960. They probably had no idea how quickly their neighborhood was about to change or that a few of them would end up with Asian neighbors. In December 1975, Congress approved the immigration of some members of a Southeast Asian group, the Hmong, to the United States under the "parole" power of the US attorney general. The Hmong had backed the American intelligence forces in Laos during the Vietnam War. A small group of Hmong refugees began arriving in the United States in 1976. Within a few years, a number of Hmong families began settling on the Old South Side, where most remained for about two decades—some longer. But long before the arrival of the Asian population, several other events took place that would change the ethnic composition of the neighborhood. (Courtesy of Kosciuszko Montessori School.)

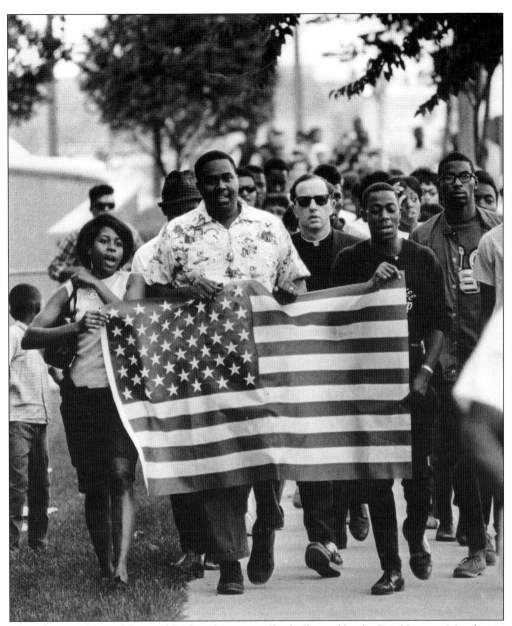

The ethnic makeup of the neighborhood was initially challenged by the Fair Housing Marches in 1967. Throughout the early 1960s, Milwaukee alderwoman Vel Phillips attempted to move a fair housing bill through the Common Council to guarantee all people the right to obtain housing in Milwaukee regardless of race, religion, or national background. On August 24, NAACP Youth Council members announced a march from Milwaukee's north side to Kosciuszko Park in the heart of the Old South Side. Kosciuszko Park was selected because the surrounding blocks were places where African Americans had sometimes been denied housing. The irony in selecting a park named after Gen. Thaddeus Kosciuszko was the fact that he had spent the greater part of his life championing the cause of Jews and serfs in his own country and American Indians in America. He was also an avid supporter of the abolitionist movement. (Courtesy of the Wisconsin Historical Society.)

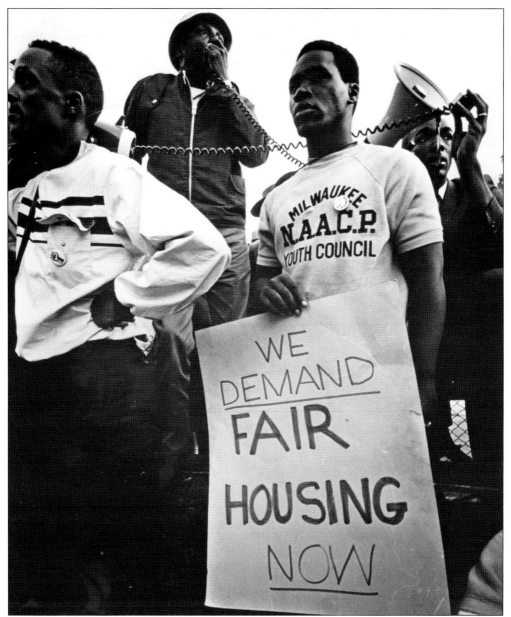

Acting as advisor and major leader of the marches was Fr. James Groppi, who had been raised in the Bay View neighborhood, just east of the Old South Side. Groppi joined St. Boniface Church in 1963 in one of Milwaukee's primarily black working class neighborhoods. While working at this parish, he became involved in the civil rights movement. In 1966, the Youth Council's first campaign with Groppi as its adviser targeted the local Order of Eagles Club because of the whites-only clause in its membership rules. In June 1967, Milwaukee Common Council members voted once again against Phillips's fair housing ordinance, prompting a series of Fair Housing Marches that climaxed in the highly publicized march to Kosciuszko. While only about 250 Youth Council members and their supporters participated in the march to Kosciuszko Park, police estimated that over 12,000 counter-demonstrators gathered on the route of the march, pelting the marchers with stones and bricks. (Courtesy of the Wisconsin Historical Society.)

Across the street from Kosciuszko Park and the marchers was the Rozga Funeral Home. A cousin of the Rozgas, Margaret Rozga (pictured here 40 years later), was marching with Groppi and the Youth Council. She later married Groppi after he left the church. James Groppi died on November 4, 1985. His funeral was held at the Rozga Funeral Home. (Courtesy of Margaret Rozga Groppi.)

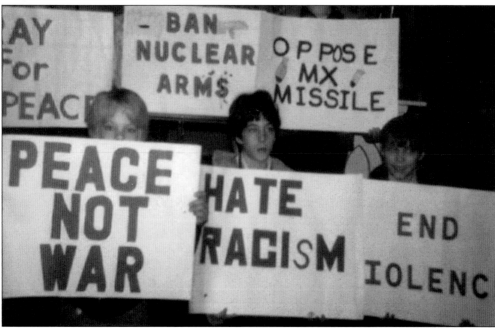

Throughout the late 1960s and early 1970s, residents of the Old South Side were becoming more socially conscious. This was particularly true of the younger generation. The above placards, made by students at St. Hyacinth School, demonstrate their rejection of war and ethnocentrism. These changes set the stage for the arrival of new populations in the area. (Courtesy of St. Hyacinth School.)

American Indians had a strong influence on the Old South Side, particularly after mid-century. Three generations of Ojibwe Porters served local youth without salaries for the Ace Boxing Club since 1960. Teddy "Cyclone" Porter (pictured here about 1920) was considered the club's visionary founder. Raised on the White Earth Reservation in Minnesota, Teddy Porter was a famed boxer during the 1920s and 1930s. (Courtesy of Diane Porter.)

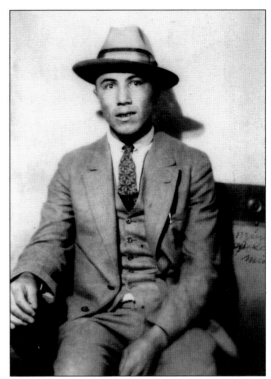

The operational founder of the Ace Boxing Club was Teddy's son, Del Porter (1933–2008). Porter, a state Golden Gloves champion in the 1950s, trained young boxers until his death, when his son Frank Porter stepped into the role. The club is located in Kosciuszko Park in the Del Porter Pavilion. (Courtesy of Diane Porter.)

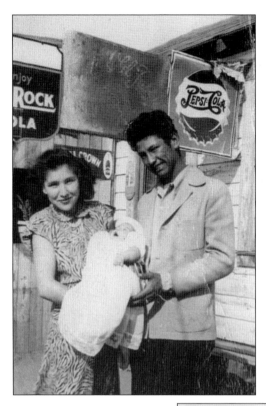

While Mexicans had been migrating to neighborhoods south of downtown Milwaukee since the 1920s, it is believed than none had lived farther south than Mitchell Street until 1956, when Valentino and Manuela Figueroa purchased a home on Burnham Street. The couple raised eight children—several of whom became leaders in the Mexican population on the Old South Side. (Courtesy of Nick Figueroa.)

Nick Figueroa (Valentino and Manuela's son) remembered his early years in the neighborhood when his family feared facing prejudice because they were Mexicans. "When we first moved here, my father told us just to pretend we were Italians." But soon he and his Polish friends realized how much they shared in common. Figueroa (pictured here around 1969) went on to lead youth programs at Kosciuszko Park years later. (Courtesy of Nick Figueroa.)

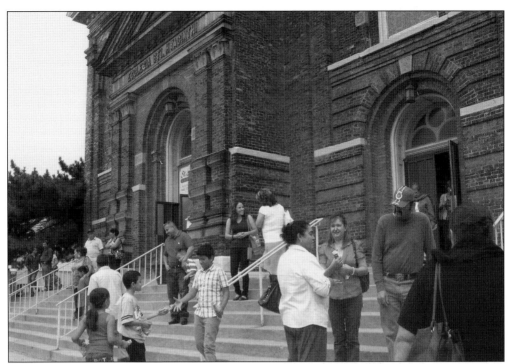

Mexican Americans, pictured at St. Hyacinth Church, were the first non-Polish people to arrive in large numbers. Extensive migration began after 1970. The Mexican and Polish residents co-existed easily. Both were overwhelmingly Roman Catholic and relied on extended family networks for economic support. Moreover, both groups were known for strong work ethics and sending money earned in America to their families back home. (Courtesy of Urban Anthropology.)

The Felix and Margarita Garcia family, shown here with their extended family, migrated to the Old South Side with the large wave of Mexicans in the mid-1970s and moved to Rogers Street. Mrs. Garcia went on to become one of the major Mexican activists in the area, being named the Milwaukee Hispanic Woman of the Year in 2001. (Courtesy of Margarita Garcia-Guerrero.)

An Urban Anthropology Inc. survey conducted in 2009 revealed that the Old South Side had become one of the most diverse areas in the city of Milwaukee. Residents claimed backgrounds from 110 nations. In 2009, the largest ethnic group was Mexican American, followed by the Poles and American Indians. Despite the success of the Fair Housing Marches in influencing the passage of a fair housing ordinance, African Americans did not migrate this far south in Milwaukee for many decades. Before the 21st century, the Old South Side population was under six percent black. However, since 2005 that number has been slowly growing. At the same time, most of the Hmong families that had arrived during the late 1970s had left the area and resettled on Milwaukee's northwest side. Above, residents of diverse backgrounds enjoyed a day and evening together at National Night Out in Kosciuszko Park in 2012. (Courtesy of Urban Anthropology.)

Two

CELEBRATIONS

Celebrations were a key ingredient in the social life of the Old South Side. The larger celebrations also had an ethnic content. For over 100 years, the Poles held area events that attracted hundreds of celebrants—sometimes thousands—and most were in remembrance of an important day in Polish history or to honor someone of Polish ancestry. As the Old South Side became more multicultural, celebrations changed. While Polish Constitution Day was still celebrated in the early 21st century, so was *Dia de los Muertos* (Day of the Dead).

The major celebrations of any era were usually held at Kosciuszko Park, which was named after Thaddeus Kosciuszko, the Polish hero of the American Revolution. Smaller celebrations—such as Christmas, communions, *quinceaneras*, or birthdays—were more family-oriented and usually held in homes or halls.

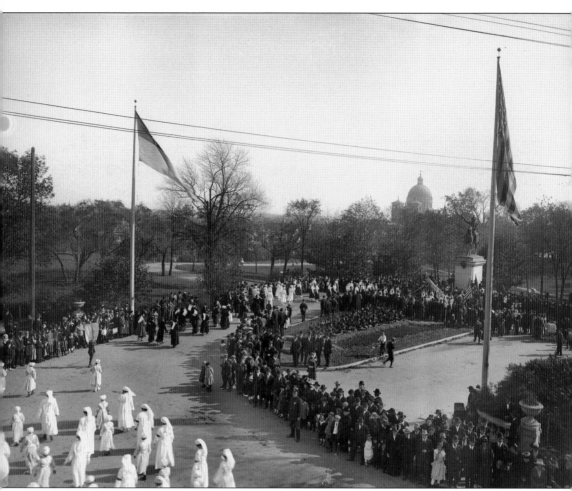

Celebrations were always a major component of Old South Side life. Most of the events had ethnic content. While the area was teeming with green space, for reasons that are unclear, Kosciuszko Park ended up being the venue for most celebrations. It might have been its central location, the lovely pond, or the daunting monument of General Kosciuszko that attracted crowds. The celebrations at "Kozy"—as locals called it—began very early and continued into the 21st century. Above, the Old South Side's Polish community gathered at Kosciuszko Park in October 1918 to celebrate the first anniversary of the formation of the Polish army in France. The parade circled the monument of General Kosciuszko. The Basilica of St. Josaphat can be seen in the distance. Parades such as this were regular events, especially on Lincoln Avenue. (Courtesy of the Wisconsin Historical Society, WHi-47638.)

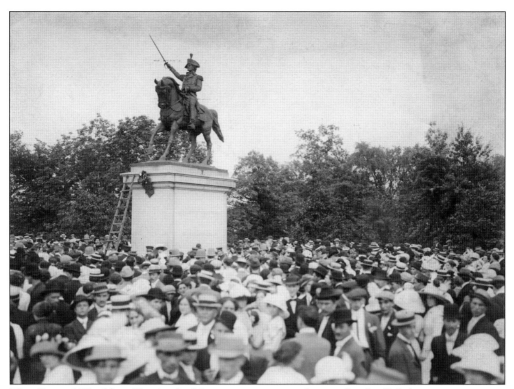

The *General Thaddeus Kosciuszko Monument*, given to the city by the Polish community, was dedicated in 1905. According to the *Milwaukee Sentinel*, 60,000 people attended the dedication. It was dedicated by Archbishop Franciszek Albin Symon (visiting from Poland) and accepted by Mayor David Rose. This photograph was taken a few years after the original dedication. (Courtesy of Kwasniewski Photographs, UWM Libraries, kw060341.)

Two unidentified girls show off their communion finery. Many celebrations on the Old South Side were religious in nature. First communions were life milestones in the Catholic Church in the United States, as they had been in Poland. Rosaries and portraits of Jesus were typical of the gifts parents and grandparents gave children celebrating their first communion on the Old South Side. (Courtesy of Kwasniewski Photographs, UWM Libraries, kw000426.)

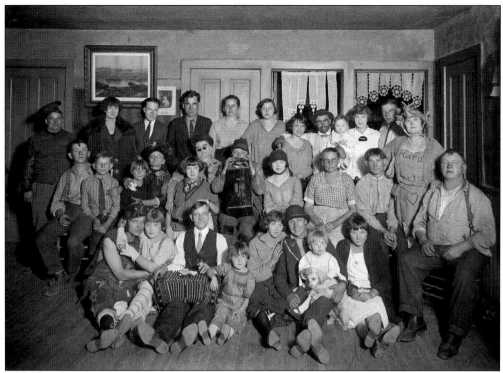

During the Great Depression, the Poles of the Old South Side would assemble for "hard times" parties in people's homes—sometimes in costume. The host commissioned local photographer Roman Kwasniewski to document this gathering. (Courtesy of Kwasniewski Photographs, UWM Libraries, kw000432.)

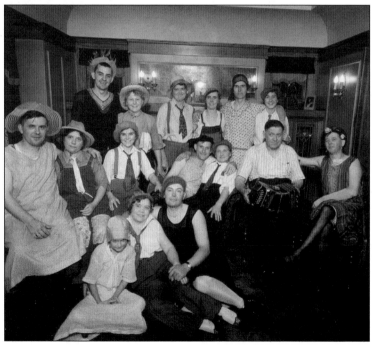

Cross-dressing is not just a contemporary phenomenon and does not necessarily denote gender disaffection. There is a rich history of cross-dressing in literature, folklore, theater, and music. People cross-dressed for a variety of reasons. At this Old South Side celebration in the 1930s, it appears to have been the theme for a hard times party. (Courtesy of Kwasniewski Photographs, UWM Libraries, kw060112.)

Dinners to aid good causes were another way the Poles celebrated. The cause being supported at this dinner in March 1934 was the building that once housed Polish soldiers who fought in World War I under Jozef Haller. The building was located on Tenth Street near Mitchell Street and maintained by Post 3, Polish Army Veterans of America. (Courtesy of Kwasniewski Photographs, UWM Libraries, kw060337.)

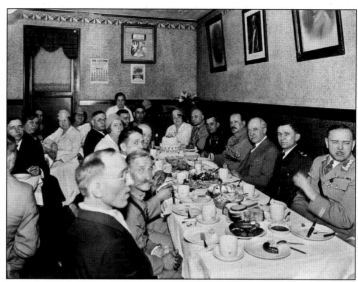

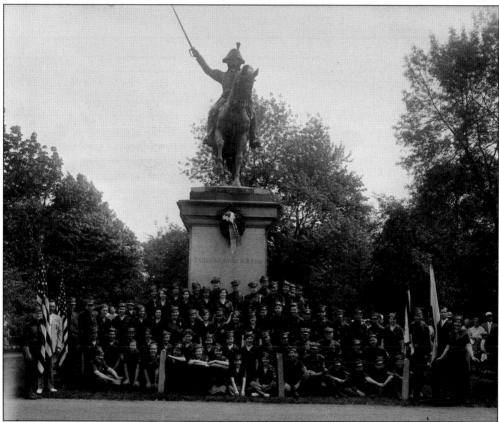

On May 3, Poles worldwide celebrate Polish Constitution Day. The day commemorates the adoption of the first constitution of its kind in Europe in 1791—a document that introduced a more democratic constitutional monarchy for the Polish-Lithuanian Commonwealth. In 1936, the Poles of the Old South Side celebrated this day at the monument of Kosciuszko. (Courtesy of Kwasniewski Photographs, UWM Libraries, kw009829.)

Another popular celebration among the Poles of the Old South Side was the Halloween party. The first immigrants celebrated All Saints Day on November 1, and people would visit the graves of their loved ones and ancestors, placing candles and flowers on the graves. The more secular Halloween, with its parties, was more of an Americanized celebration. (Courtesy of Kwasniewski Photographs, UWM Libraries, kw000768.)

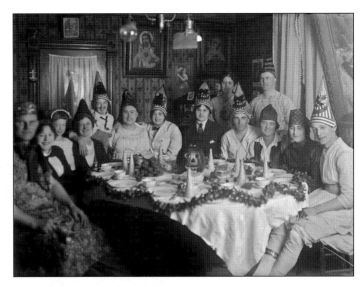

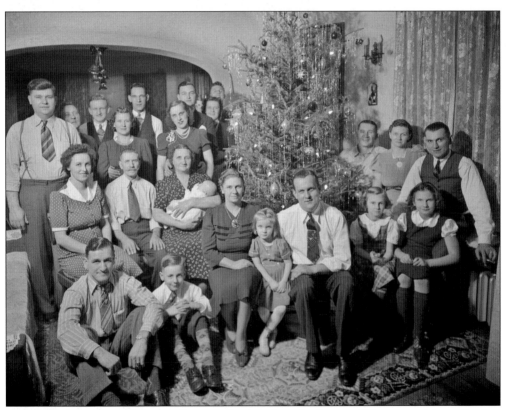

A popular custom on Christmas Eve was sharing the *opłatek,* an edible, paper-thin wafer that Poles shared with family members before sitting down to the *Wigilia* meal. Here, the Serbiak clan gathered in 1941 on Seventh Street to celebrate Christmas Eve. (Courtesy of Kwasniewski Photographs, UWM Libraries, kw000868.)

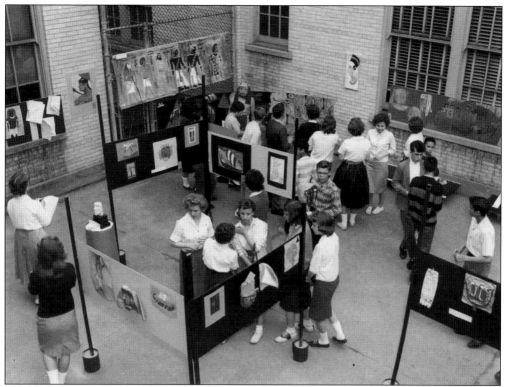

In the 1950s and 1960s, Kosciuszko School on Windlake Avenue on the Old South Side held folk fairs that included art exhibits of students and stage performances that often portrayed people of different ethnic backgrounds. At the time, the neighborhood was still solidly Polish. Pictured are students and their supporters viewing art. (Courtesy of Kosciuszko Montessori School.)

This later folk fair held at Kosciuszko School about 1960 featured American Indian dancers. At the time, several American Indian families were living on the Old South Side but were not necessarily integrated into community life. It is not known whether any of the dancers depicted here were local residents. (Courtesy of Kosciuszko Montessori School.)

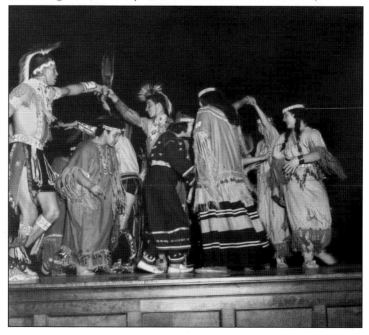

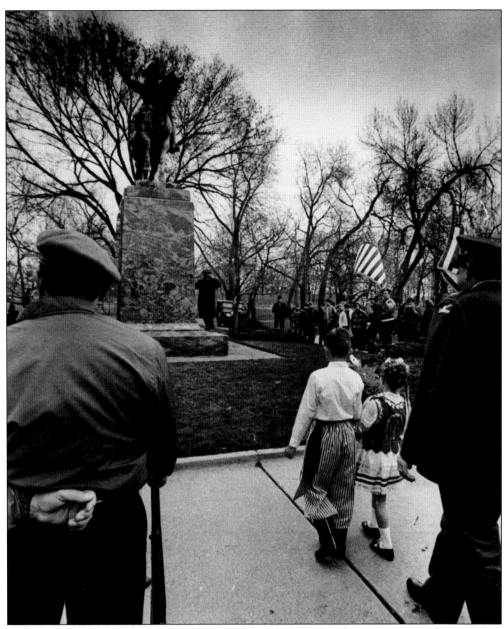

A distinctive feature of the Polish Old South Side was the painstaking planning and consistency of their celebrations. Polish Constitution Day was observed on the Old South Side until the 1980s. Here, Polish celebrants—some in traditional dress and others carrying American or Polish flags—gathered by the statue of Thaddeus Kosciuszko in Kosciuszko Park in May 1971. The park marked the end of their parade for Polish Constitution Day, which had begun at St. Stanislaus Church, the first Polish Catholic church in Milwaukee, on Sixth Street and Mitchell Street. While the event was suspended for several decades when Poles were migrating out of the Old South Side, the celebration returned in 2012, as part of the Gathering by the Waters event. It is slated to become a biannual event at Kosciuszko Park. (Courtesy of Historic Photo Collection/ Milwaukee Public Library).

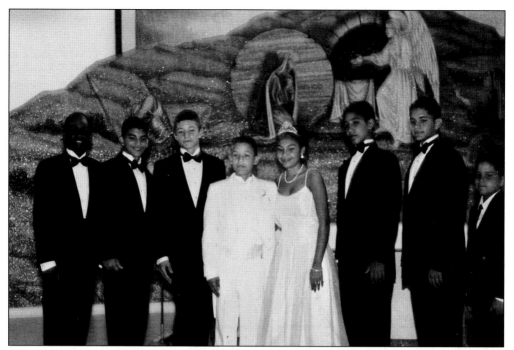

The arrival of Mexican Americans ushered in a new ensemble of celebrations. A major event was the *quinceanera* or *Fiesta de Quince Anos*, which is the celebration of a girl's 15th birthday. Pictured is the *quinceanera* of Nadia Garcia in 2001. (Courtesy of Margarita Garcia-Guerrero.)

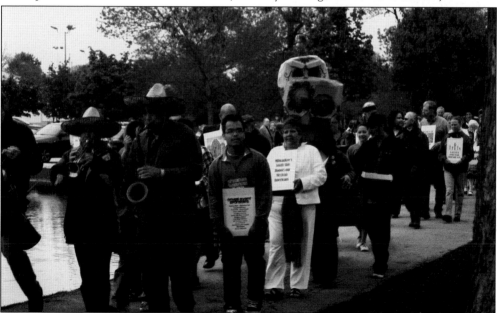

On May 5, 2012, the Old South Side hosted a tri-cultural event called Gathering by the Waters. Community members from its three largest ethnic groups (Polish, Mexican, and American Indian) gathered for a weekend of celebration. Here, a large procession winds its way through Kosciuszko Park, including Polish, Mexican, and American Indian musicians, business owners, organizational leaders, and families. (Courtesy of George Baker.)

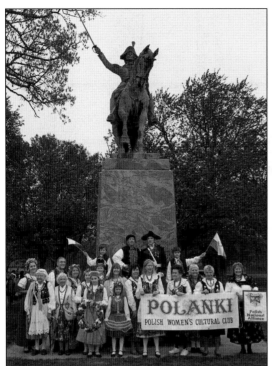

When the Poles returned to their old neighborhood to celebrate Polish Constitution Day in 2012, they selected Kosciuszko Park and the monument again as focal points of the celebration. The Kosciuszko Monument serves just as powerful a role for Poles today as it did in their early years on the Old South Side. (Courtesy of Alex Trumbull-Holper.)

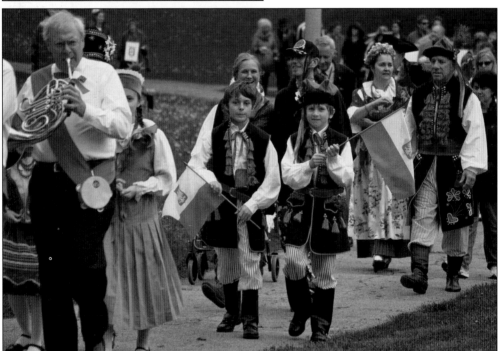

The Polish procession marchers—in full ethnic dress—made their way through their old neighborhood park, toward one of the most prominent beacons of their ethnic identity, the Basilica of St. Josaphat. Some Poles living outside the Old South Side are still members of this parish. (Courtesy of George Baker.)

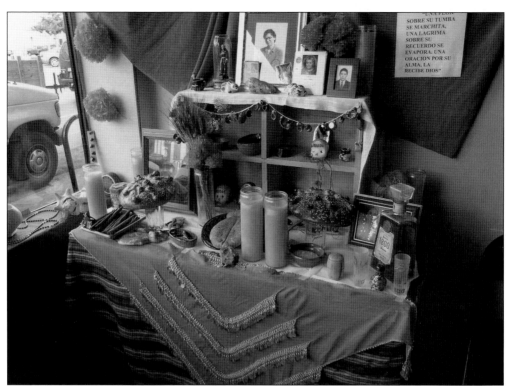

"UNA FLOR
SOBRE SU TUMBA
SE MARCHITA,
UNA LAGRIMA
SOBRE SU
RECUERDO SE
EVAPORA, UNA
ORACION POR SU
ALMA, LA
RECIBE DIOS"

In 2006, the Lincoln Village Business Association and member merchants sponsored a Day of the Dead window display and procession. Day of the Dead (*Día de los Muertos*) is a Mexican holiday focusing on remembrance of passed family and friends. Traditions connected with the holiday include building private altars to the deceased like the one pictured. (Courtesy of Urban Anthropology.)

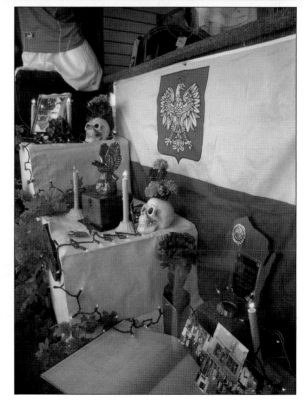

Merchants of any ethnic persuasion on the Old South Side were encouraged to display altars to honor their dead on Día de los Muertos. Here, the owners of local Polish-run store Stefan's Soccer celebrated their deceased ancestors with their own unique display. Local restaurants also have annual Day of the Dead events on the Old South Side. (Courtesy of Urban Anthropology.)

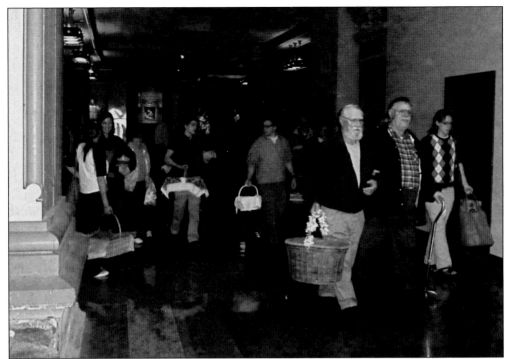

A Polish tradition long maintained on the Old South Side is the blessing of the Easter baskets. Here, residents leave mass before Easter Vigil at the Basilica of St. Josaphat in April 2012, where the priest blessed the food and drink items in their baskets. Most families consumed these items for Easter brunch, but some donated them to the local parish pantries. (Courtesy of Alex Trumbull-Holper.)

Cultural celebrations on the Old South Side are known for their diverse ethnic menus. Here, community members and city officials alike gather to enjoy the homemade ethnic delicacies including pumpkin soup, guacamole, fry bread, and pierogies. These recipes were specifically selected to represent menu items from American Indian, Polish, and Mexican cultures. (Courtesy of George Baker.)

Three

SPORTS

Sports were the rage of the Old South Side. While involvement in sports was sometimes a force for cultural assimilation in other neighborhoods, this was never the case here. The Kosciuszko Reds, a sandlot Polish baseball team, was legendary during the early Polish era. During later years, soccer and the Felix Mantilla Little League drew multiethnic participants and spectators at area parks. Boxing—which produced a few Polish heroes in the early 20th century—became the domain of the American Indians by the late century. And ice skating on the lagoon of Kosciuszko Park brought all groups together for over a century.

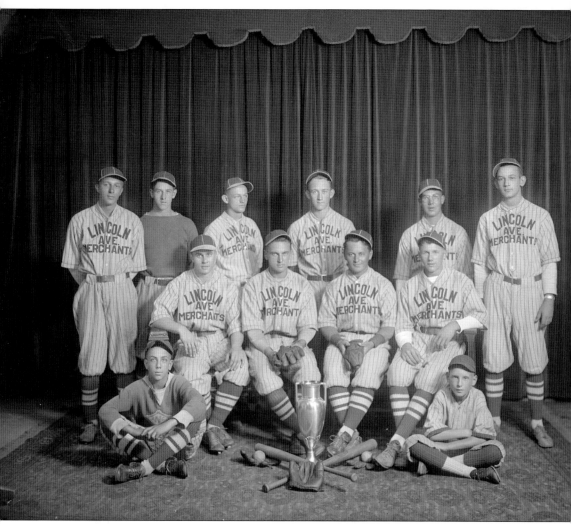

In the early 20th century, baseball had become so popular that some Polish leaders worried it was Americanizing youth too quickly. In fact, leaders in Chicago's Polonia organized their own baseball league in 1913 to keep young people from assimilating into the Anglo American world though the sport. Soon Milwaukee followed suit. Within a few years, the Kosciuszko Reds had established themselves as the sandlot darlings of the Old South Side. The Polish semiprofessional team operated between 1909 and 1919, a time of great upheaval due to World War I. The Reds, often called the "Koskys," began competition in the City League and then shifted to the Lake Shore League. They won four championships during the decade, and were so legendary that they became the topic of several publications, including Neal Pease's "The Kosciuszko Reds 1909–1919: Kings of the Milwaukee Sandlots" in *Polish American Studies,* and George Reimann's *Sandlot Baseball in Milwaukee's South Side.* (Courtesy of Kwasniewski Photographs, UWM Libraries, kw000916.)

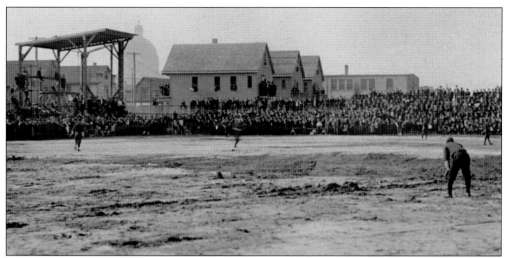

The Kosciuszko Reds played at the South Side Park, which once operated at the corner of what is today Harrison Avenue and Fifth Street. The Koskys won the City League championship in 1911, and the team entered the prestigious Lake Shore League the following year. This was the top semiprofessional circuit in Wisconsin and northern Illinois. (Courtesy of Kwasniewski Photographs, UWM Libraries, kw060339.)

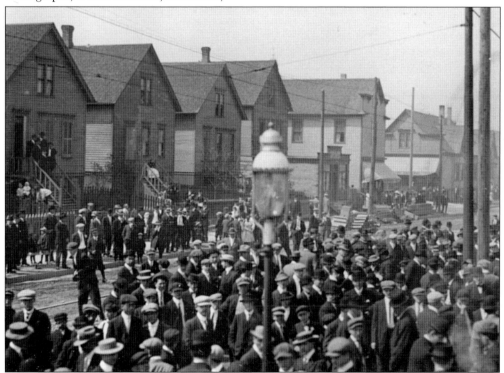

Hundreds of people flooded the streets on their way to the Peters Union Giants game. No Kosky game ever received as much attention as the team's first appearance in the Lake Shore League in May 1912. The Peters Union Giants were a traveling African American squad from Chicago, with Negro League stars such as outfielder Mike Moore and Ted "Double Duty" Radcliffe. (Courtesy of Kwasniewski Photographs, UWM Libraries, 060338.)

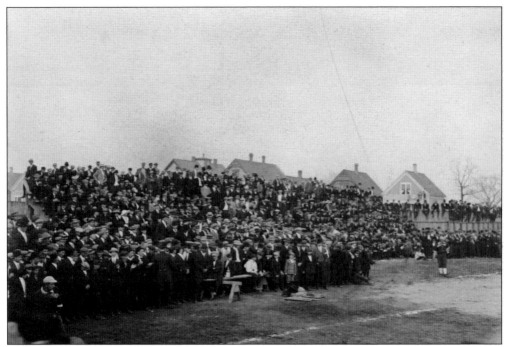

Real estate developer Louis Fons owned the baseball team and built the South Side Park. Over the years, team sponsor Fons became preoccupied with his busy real estate business, politics, and his advocacy for an independent Poland after World War I. He disbanded the team in 1919 and tore down the ballpark the same year. (Courtesy of Kwasniewski Photographs, UWM Libraries, kw060340.)

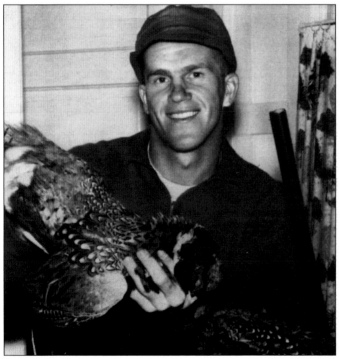

The Old South Side produced several professional baseball players, including major leaguer Tony Kubek. Anthony Christopher Kubek (born 1936) played for the New York Yankees between 1957 and 1962. He was voted Rookie of the Year for the American League in 1957 and played against the Milwaukee Braves in the World Series that same year. Here he is in 1958 pheasant hunting in Wisconsin. (Courtesy of Steven Milton Lackey.)

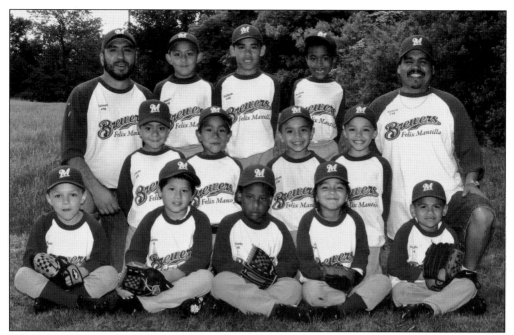

Felix Mantilla played for the Milwaukee Braves between 1956 and 1961. He met his wife Kay in Milwaukee, and the city remained his home for decades. In his honor, the United Community Center established the Felix Mantilla Little League serving primarily Latinos ages 4 to 15. Above are the champions for the 2011 season, at the Old South Side's Baran Park. (Courtesy of the Felix Mantilla Little League.)

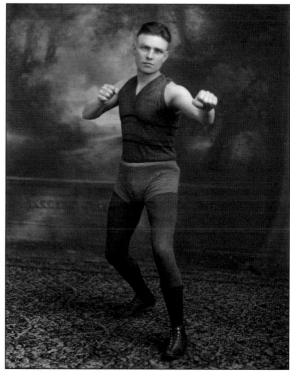

Baseball was not the only rage on the Old South Side. Boxing was equally popular. One of the local heroes in the early 20th century was a Polish boxer named Anton Chmurski, otherwise labeled "Kid Moore." Chmurski (seen here in 1915) and his wife, Catherine, resided on the Old South Side. (Courtesy of Kwasniewski Photographs, UWM Libraries, kw000604.)

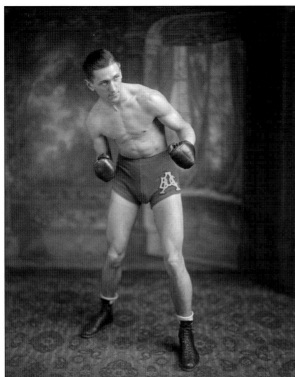

Boxing suffered during the Great Depression to the extent that there was no world heavyweight champion in 1930. A south side boxer of some repute during those difficult times was Erwin Franks, seen here the day after Christmas in 1931. He lived on Eighteenth Street near Oklahoma Avenue, just beyond the southern boundary of the Old South Side. (Courtesy of Kwasniewski Photographs, UWM Libraries, k2000885.)

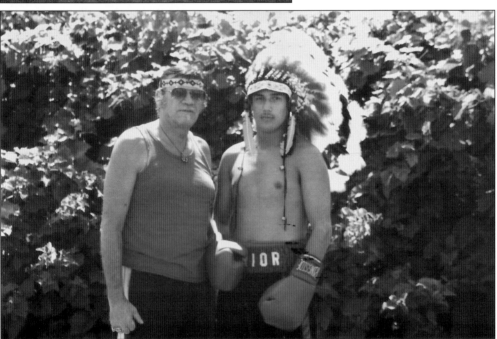

The American Indians took boxing prominence in the middle of the 20th century with the Ojibwe Porter family, who opened the Ace Boxing Club in 1960. Here, Golden Gloves champion Del Porter is pictured with his nephew Tyrone Porter, a professional boxer known as "The Warrior." The clubhouse is located at Kosciuszko Park in the Del Porter Pavilion. (Courtesy of Diane Porter.)

The members of Ace Boxing have won over 50 Golden Gloves championships. In addition to boxing, they have performed public services throughout the Old South Side, doing neighborhood clean-ups, collecting donations for food pantries, shoveling walks for the elderly, and helping residents with yard work. (Courtesy of the Ace Boxing Club.)

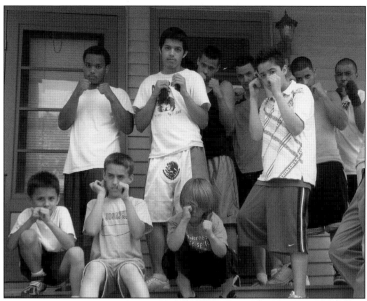

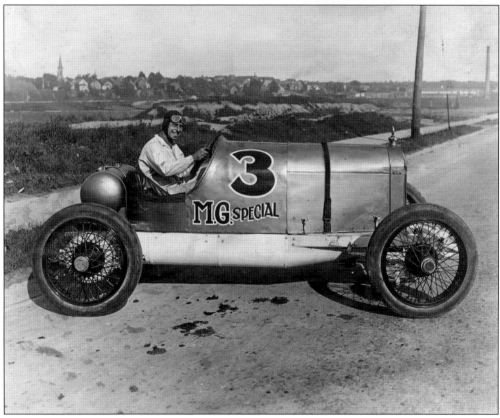

Other sports also intrigued residents of the Old South Side. One was auto racing. Barney Czerwinski, who owned Czerwinski Real Estate on the southeast corner of Sixth Street directly across from the Basilica of St. Josaphat, is shown here about 1920 with his race car. (Courtesy of Kwasniewski Photographs, UWM Libraries, kw060342.)

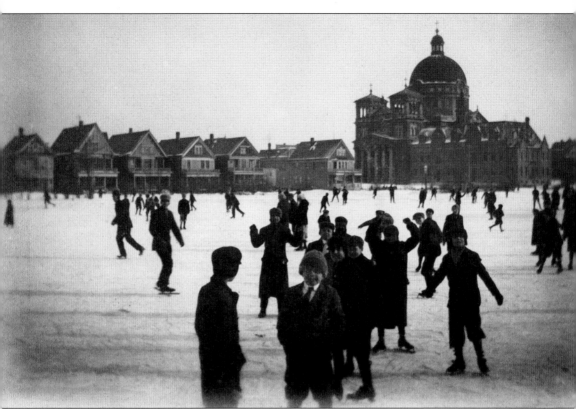

During the Polish era on the Old South Side, the pond at Kosciuszko Park became a skating rink during the coldest months of winter, as shown here in 1910. Residents from miles around anxiously anticipated the time when the pond was frozen and safe for skating. Of course, safety was a relative concept. A longtime resident described his experiences on the pond: "We didn't think much about safety then. We always took falls. Some broke bones. I used to go out with skates two sizes too big for me, slipping in and out of the skates. We played a game called the whip where a whole line of kids would whirl around and someone at the end would get spun around so fast, and if you hit a little bump in the ice—well you can imagine what was going to happen. We only could play the whip if our parents weren't around." (Courtesy of Kwasniewski Photographs, UWM Libraries, kw000204.)

During most of the 20th century, the skating program was supported by the Milwaukee County Department of Parks. In later years, the park system was no longer able to support every skating program at Milwaukee County parks. This one was suspended in the 1990s. Three young residents of the Old South Side are pictured showing off their skating skills at Kosciuszko Park. (Courtesy of Kwasniewski Photographs, UWM Libraries, kw060250.)

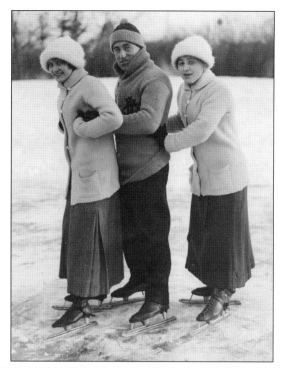

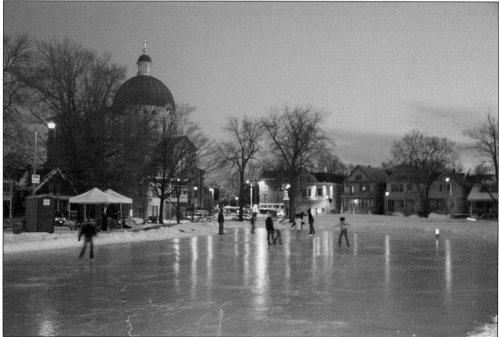

In 2008, Urban Anthropology Inc., the resident association for the Lincoln Village and Baran Park neighborhoods, reopened the skating program at Kosciuszko Park. Skates were available for use at no cost to participants, and hot chocolate was often served. A century after photographer Roman Kwasniewski captured the pastime on the lagoon, the children in this 2008 photograph once again enjoyed the sport. (Courtesy of Kathrin Fiedler Schmid.)

The 1970s were important for many reasons. Mexican Americans were migrating to the Old South Side in large numbers. In 1970, Mexico hosted the World Cup and the home team reached the quarterfinals. Participating in five World Cups before 1970, the Mexican team recorded only one win in the tournaments, and that was over Czechoslovakia, 3-1 in 1962. However, the 1970 events spurred a great interest in the sport of soccer throughout Mexico and the Mexican Diaspora. Since then, soccer has been the sport most often played in the parks of the Old South Side. On a Sunday afternoon at Kosciuszko, Baran, or Pulaski Parks, it is not unusual to see a Polish or Serbian soccer team playing a Mexican one. At Kosciuszko Park, a soccer game is played at least three times every weekday and more often on weekends. (Courtesy of Urban Anthropology.)

Four

ARTS

The arts of the Old South Side were also teeming with ethnic content. During the century of Polish domination, the Poles produced opera and amateur theater performed in the Polish language or with specific Polish content. In the later multicultural period, the only theatrical production performed in this neighborhood was about the civil rights movement of the 1960s and how it affected the Old South Side. The play, performed in 2012, was also the first theatrical production at the Basilica of St. Josaphat.

Visual arts also changed. For example, the Polish paper art of *wycinanki* so often seen in homes and businesses on the Old South Side began to share space with the Mexican paper art of *papel picado* by the 1990s. Both art forms involved cutting paper into evocative designs.

The Old South Side also spawned artist clubs. In the 21st century, the neighborhood has its own Old South Side Artist Guild that puts on multicultural exhibitions every July and sponsors ethnic musicians for area park events.

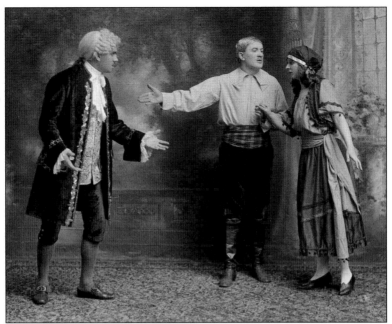

Between 1920 and 1928, the area's Polish Opera Club presented operas such as *Martha*, *Il Trovatore*, *Last Waltz*, and *Masked Ball* in Milwaukee and Chicago. The Opera Club was organized and directed by longtime Milwaukee music director John C. Landowski and noted Milwaukee actor Anthony J. Lukaszewski. The Milwaukee Polish Opera Club was the first in the United States to produce *Halka (Helen)* in its entirety. Before rehearsals could begin, Landowski had to rewrite nearly 4,000 pages of music. *Halka* was the first of the Opera Club's productions to be performed in Chicago as well as in Milwaukee, and it was the most successful endeavor of all. These performance stills feature cast members from a production of the *The Bohemian Girl*. (Both, courtesy of Kwasniewski Photographs, UWM Libraries, kw000919 (above) and kw000918 (below).)

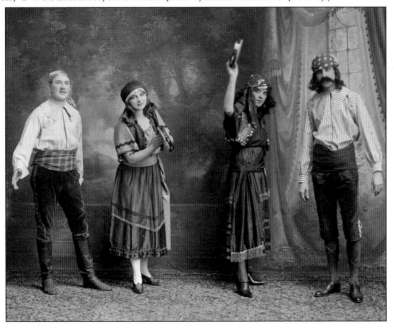

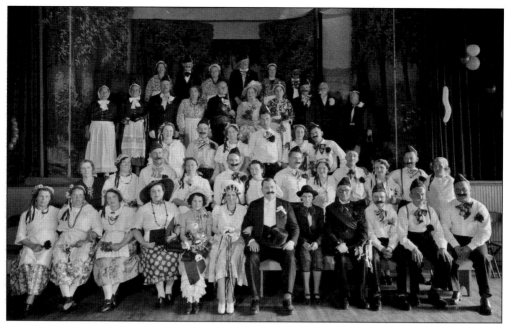

The Polish Fine Arts Club produced light comedies and more serious works as well as operas and concerts, including *Words and Music* (1932), *Ladies and Hussars* (1932), *Yours to Command* (1935), *Children Be Good* (1937), *Ach Te Wakacje* (1937), and *Polonaise* (1939). The School Mothers Society, pictured here, presented *A Country Wedding* at St. Adalbert's Church in 1939. (Courtesy of Kwasniewski Photographs, UWM Libraries, kw000868.)

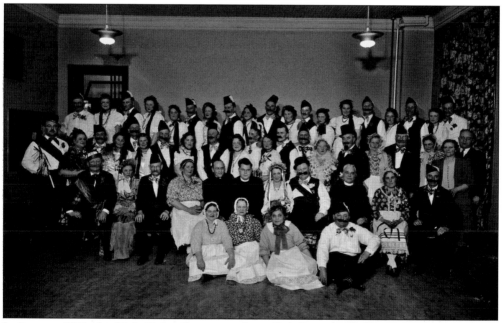

In January 1941, the Holy Name Society performed *A Country Wedding* (*Wiejskie Wesele*) on Rogers Street on the Old South Side. The performance depicted a Polish village wedding with traditional dress and Polish dances and songs. (Courtesy of Kwasniewski Photographs, UWM Libraries, kw000865.)

Amateur theater was also popular on the Old South Side. Boleslaus Goral wrote in Watrous's 1909 *Memoirs of Milwaukee County* that he could hardly find a Polish parish without a dramatic society. In 1908, the Polish Theatre of Milwaukee was established, performing in Polish parishes in and beyond the Old South Side. Here, the St. Alexander dramatic circle performed a play,

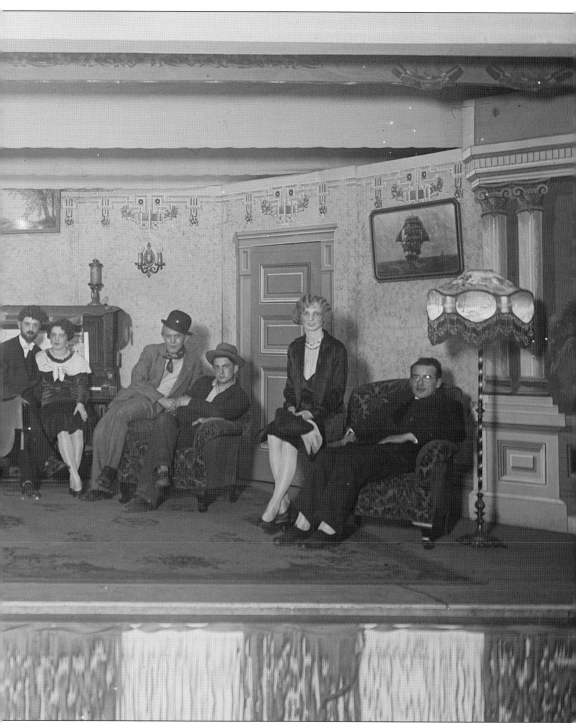

date unknown. The church was located just south of the southern boundary of the Old South Side on Eleventh Street. The St. Alexander dramatic circle was mentioned in a *Sentinel* article on August 11, 1930, as performing with their St. Cecilia choir on a boat excursion to Chicago. (Courtesy of Kwasniewski Photographs, UWM Libraries, kw001303.)

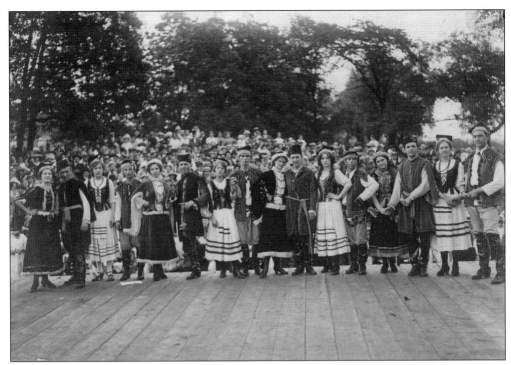

Some groups were founded for the specific purpose of performing Polish music, theater, and dance. In the pre-television age, amateur performances were a popular form of entertainment, and no patriotic event was complete without one. Polish dance troupes remained on the Old South Side until 2012, when the Krakow Polish Dancers lost their home base to the widening of the Kinnickinnic River. (Courtesy of Kwasniewski Photographs, UWM Libraries, kw060132.)

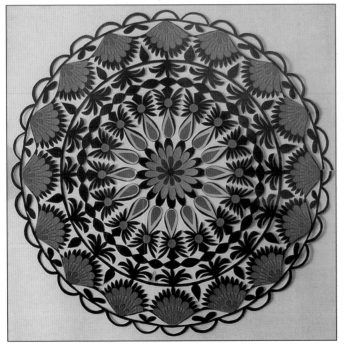

Wycinanki, Polish paper art, was brought to the Old South Side by immigrants. The art became a popular folk craft in the mid-1800s when Polish peasants decorated ceiling beams of countryside cottages. Multiple layers of colored paper were folded, cut, and sometimes embossed to create stylized patterns. This example was brought to America from Poland by the Konkel family late in the 20th century. (Courtesy of Urban Anthropology.)

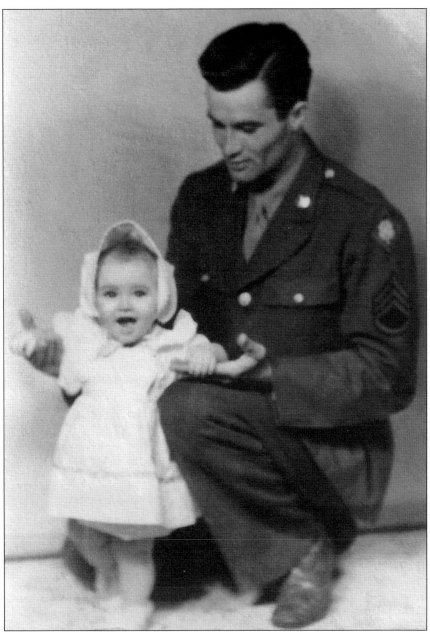

William Thomas Lackey (1919–2003) was a well-known WPA artist under the New Deal Federal Art Project program who lived on Seventh Street in the 1950s. Of Creek and Cherokee ancestry, he worked as a freelance artist for the city's Bercker Studios. At Bercker's, Lackey was the model for the original Indian logo of the Milwaukee Braves. His other work included *Treasure Chest* comic books and a long history of book illustrating for the *Catholic Digest* and the Catechetical Guild. Lackey's illustrations and paintings have been on permanent exhibit at the Cowboy Museum in South Dakota and at locations all over the Old South Side, including the Old South Side Settlement Museum and Kosciuszko Park Community Center. Lackey's daughter Jill Lackey (pictured here as an infant) later returned to the neighborhood and was instrumental in founding Urban Anthropology Inc. and the settlement museum. (Courtesy of Jill Lackey.)

Jonathan Williams, director of the Jargon Society, once wrote that "Lorine Niedecker is the most absolute poetess since Emily Dickinson." While Niedecker made her home on Black Hawk Island in Wisconsin, in 1963 she met and married Albert Millen of the Old South Side, an industrial painter at Ladish Drop Forge, and moved to the neighborhood. During her Milwaukee years, she wrote poetry on the neighborhood that mentioned the various landmarks, including the Basilica of St. Josaphat. Her books published after her move to the Old South Side included *T & G: The Collected Poems, 1936–1966, North Central*, and *My Life By Water*. Niedecker was the subject of a 2011 biography, *Lorine Niedecker: A Poet's Life*, by Margot Peters. While researching the book, Peters visited the home where Niedecker had once lived on the Old South Side in order to capture the ambience of the poet's Milwaukee years. (Courtesy of Hoard Historical Museum.)

Mexican *papel picado* art gradually overtook Polish *wycinanki* as the most ubiquitous paper art seen in homes and businesses on the Old South Side. The art form, which goes back to the ancient Aztecs, is produced in many ways, often by cutting a design on tissue paper with small chisels. This *papel picado* was displayed in a store window on Lincoln Avenue about 1985. (Courtesy of Urban Anthropology.)

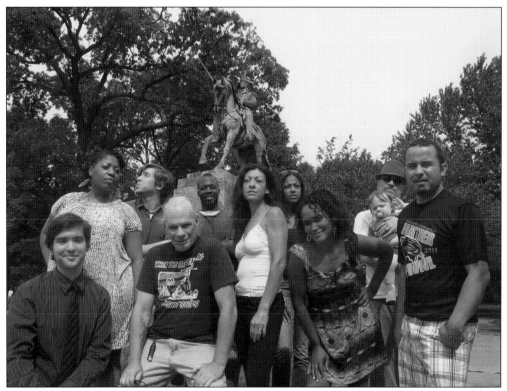

In 2012, the Basilica of St. Josaphat hosted live theater for the first time. The performance of *The March to Kosciuszko* depicted the Fair Housing Marches to the Old South Side in 1967. The cast members were, from left to right, (first row) Chris Goode and Ken Spears; (second row) Linetta Davis, Ryan Nelson, Damion Thompson, Beth Reichart, Bria Cloyd, Dionne Walker, Jason Drake-Hames, and Luis Saavedra. (Courtesy of Urban Anthropology.)

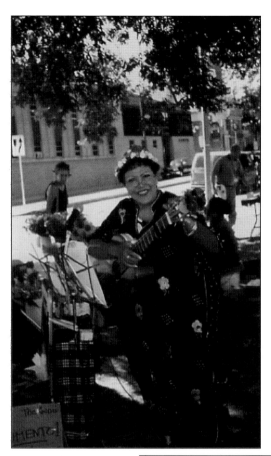

Musicians were always regulars on the streets of the Old South Side. Here, Lupita Bejar-Verbeten performs Mexican favorites for an audience at Kosciuszko Park in 2008. Lupita was also one of the Old South Side's favorite clowns for community events. Like so many of the immigrants in this neighborhood, Bejar-Verbeten used her extra income from performing to support relatives back home in Mexico. (Courtesy of Urban Anthropology.)

Another musician often seen performing for onlookers at Kosciuszko Park was Ray Krawczyk. He and his American Indian wife, Cecelia, were raised on the Old South Side. They often returned to Kosciuszko Park, where Krawczyk and his friends performed Polish favorites for the locals and his wife exhibited her Oneida beading art. (Courtesy of Urban Anthropology.)

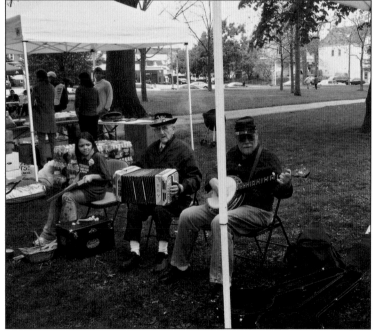

Five

INSTITUTIONS

The residents of the Old South Side developed their own institutions, including churches, schools, service agencies, and newspapers. Most of the Poles, Mexicans, and American Indians who resided on the Old South Side over the generations practiced some form of Catholicism. The crowning achievement of the early Poles was the construction of the Basilica of St. Josaphat, which came to symbolize neighborhood traits other than just faith. It pointed to the work ethic, sacrifice, perseverance, and self-sufficiency of the people. One would struggle to find a person on the streets of Milwaukee who would not immediately identify the basilica as a place built by the hands of the residents. The churches were also places where residents socialized or where they sometimes secured food, counseling, or monetary assistance. Moreover, the churches financed and operated the early schools.

However, just because most of the residents practiced Catholicism does not mean that there was unity in the faith. One of the largest controversies in the history of the Old South Side began at the turn of the 20th century and continued for 25 years. It was the battle between Michal Kruszka, the editor of the Polish language newspaper, the *Kuryer Polski*, and the Milwaukee archbishop, S.G. Messmer. It began when Messmer claimed that Polish priests were not yet Americanized enough to advance in the church hierarchy. The *Kuryer* also reported on local complaints that the construction of the basilica had overly burdened the parishioners. In a related incident, a group of area Catholics rebelled against the Roman Catholic Church and formed a parish of the Polish National Catholic Church on the Old South Side. They named it the Holy Name of Jesus.

Until the middle of the 20th century, few services were available from government or nonprofit agencies. Residents during those early years formed their own associations—mainly federations and veterans' organizations—to access services such as health insurance, housing, and settlement assistance. This would change late in the 20th century when government agencies and foundations funded a succession of area health, human service, and business assistance organizations.

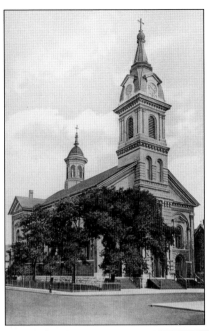

More than any other ethnic group in Milwaukee, the Poles built churches. Founded in 1883, St. Hyacinth Parish still flourishes on Becher Street. The church hosted one of the earliest food pantries, believed to have opened in 1905. The parish shifted with the demographics, and in the 21st century, the Spanish Sunday mass is often standing room only. (Courtesy of the Milwaukee Public Library, RW1927FC.)

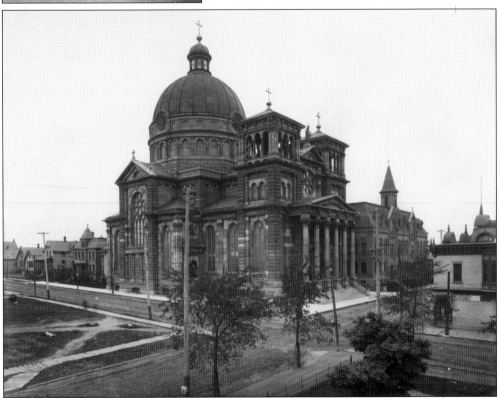

Since the turn of the 20th century, the beacon of the Old South Side has been the Basilica of St. Josaphat. The monumental achievement of Milwaukee's Polish community stands on Sixth Street and Lincoln Avenue. Its dome, which can be seen for miles in all directions, has been the topic of noted poets such as Lorine Niedecker. (Courtesy of the Basilica of St. Josaphat Foundation.)

The original congregation of
St. Josaphat was founded in the
1880s. In 1896, Pastor Wilhelm
Grutza commissioned prominent
architect Erhard Brielmaier to
design a structure to accommodate
the rising number of parishioners.
Although Brielmaier's plans
originally called for brick
construction, eventually salvage
material from the demolished
Chicago Federal Building was
used. (Courtesy of the Basilica
of St. Josaphat Foundation.)

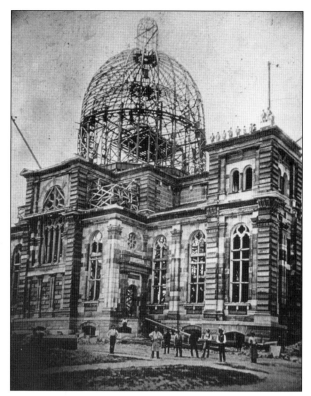

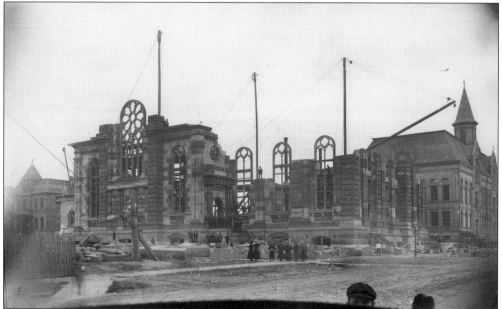

Grutza purchased 200,000 tons of material from the demolished Chicago Federal Building for
$20,000 and delivered all of it to Milwaukee on 500 railroad flatcars. The entire building—including
its carved stone, wooden doors, light fixtures, ornamental bronze railings, and doorknobs—
was purchased and used for the construction of the basilica. (Courtesy of the Basilica of St.
Josaphat Foundation.)

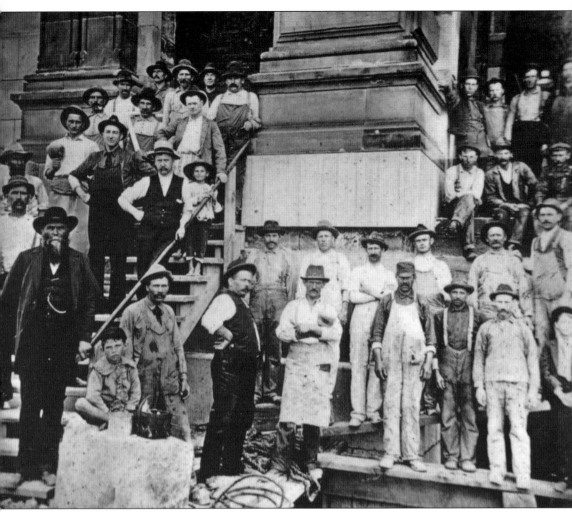

Unskilled parishioners and local residents completed the labor under Brielmaier's careful direction. They were responsible for much of the excavation and many of the construction tasks, such as mixing and pouring the cement. Women of the parish carried away dirt in their aprons while the men followed Brielmaier's plans. Many of the more than 12,000 parishioners contributed what they could financially to the effort, but costs were high. Despite all of the volunteer labor and financial contributions, the parish incurred considerable debt and was eventually turned over to the Conventual Franciscan Friars who assumed most of the debt. The Basilica of St. Josaphat was formally dedicated on July 21, 1901, following a high mass presided over by Archbishop Francis Xavier Katzer. In 1929, the basilica was designated as the third minor basilica in the United States by Pope Pius XI. (Courtesy of the Basilica of St. Josaphat Foundation.)

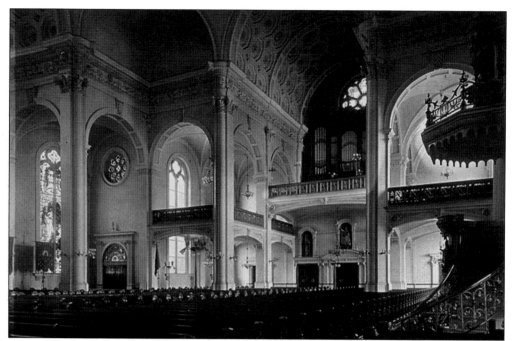

Decoration on the interior of the Basilica of St. Josaphat was completed in 1926 by artists Conrad Schmidt and Gonippo Raggi. Oil paintings depicting biblical scenes adorned the walls and inner dome. Ornamental plasterwork set in gold leaf embellished the columns. The completed church sat 2,400 members, making it the city's largest place of worship. However, an electrical fire in 1940, a lightning storm in 1947, and a windstorm in 1986 left the basilica in need of repair. With the help of the Franciscan Order and local Polish businesses, a restoration project was initiated. When the basilica was restored in the early 1990s, Conrad Schmidt Studio was the firm selected to repeat the work. (Above, courtesy of the Basilica of St. Josaphat Foundation; below, courtesy of Milwaukee County Historical Society.)

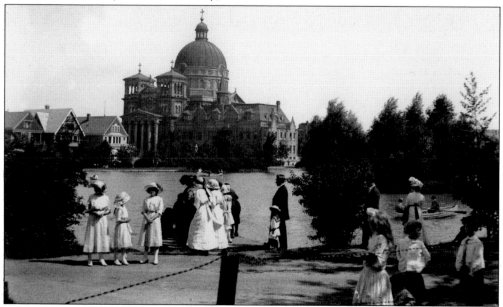

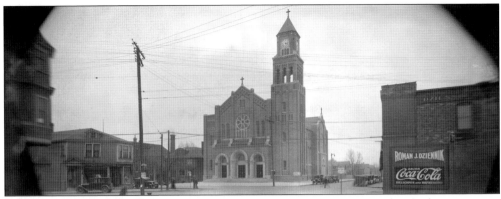

With the growth of the Polish community on the Old South Side, the Basilica had competition. In 1908, five lots were purchased on the corner of Becher and Nineteenth Streets where the cornerstone for St. Adalbert's Church was laid and blessed under the guidance of Rev. Michael Domachowski. Today, the church is one of the favorite destinations of the Latino population. (Courtesy of Kwasniewski Photographs, UWM Libraries, kw000444.)

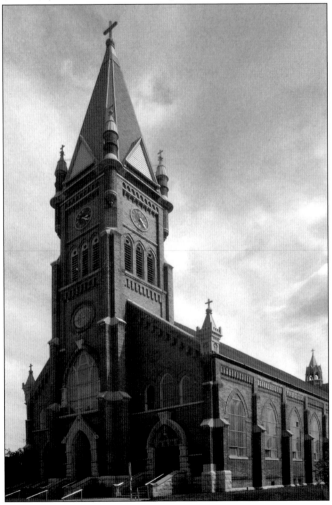

Another Polish church, the Holy Name of Jesus, emerged during that period. In the March 11, 1914, issue of the *Kuryer Polski*, Rev. Francis Bonczak wrote, "It is high time that the enlightened Polish people of Milwaukee should organize, and as a free nation build a Free National Church." Residents gathered the following week to organize the parish, which was consecrated in 1917. (Courtesy of Urban Anthropology.)

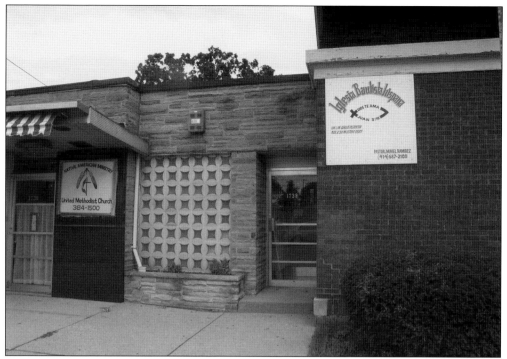

As the Old South Side moved from a melting pot Polonia to a diverse "salad bowl," its churches reflected the change. Two ethnic faith communities have been situated next door to one another on Eleventh Street and Maple Avenue since the turn of the 21st century. The United Methodist Church serves primarily American Indians, and Iglesia Bautista Hispana serves primarily Latinos. (Courtesy of Urban Anthropology.)

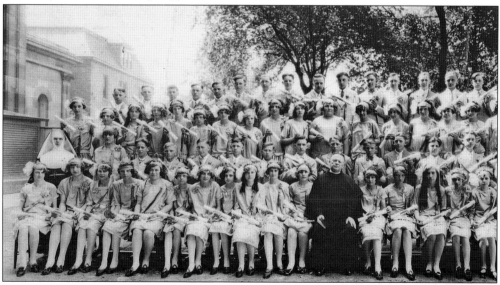

During the Polish era, schools usually grew out of parishes. St. Josaphat Parish School (seen here in 1927) was affiliated with the original St. Josaphat's congregation, before the Basilica was built. During its early years, the school was located next to the basilica, and in the late 1970s the school moved several blocks away on Lincoln Avenue. (Courtesy of St. Josaphat Parish School.)

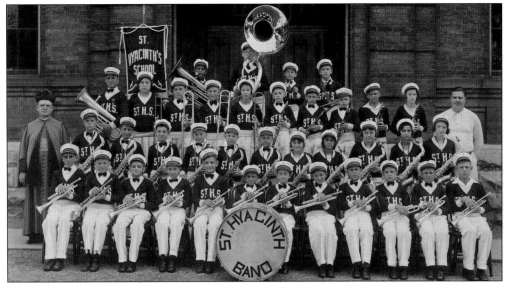

St. Hyacinth School on Becher Street was built in the 1880s. It served the Old South Side until its closing in May 1990, only months before the passage of the Milwaukee Parental Choice program that provided vouchers to families so that low income children could attend schools of their choice, helping subsidize private schools. Above is the school band of 1931. (Courtesy of Kwasniewski Photographs, UWM Libraries, kw000439.)

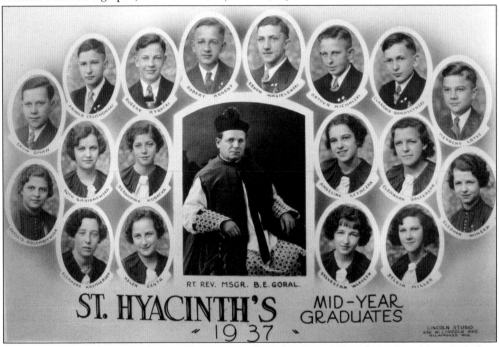

Above are the "mid-year graduates" of St. Hyacinth's School in 1937, with Rt. Rev. Msgr. Boleslaus Edward Goral. Goral was a controversial figure on the Old South Side. An author of several books on the Polish language, Goral also was the editor in chief of the *Nowiny*, a Polish language newspaper created in opposition to the *Kuryer Polski* (see section on newspapers at chapter's end). (Courtesy of St. Hyacinth School.)

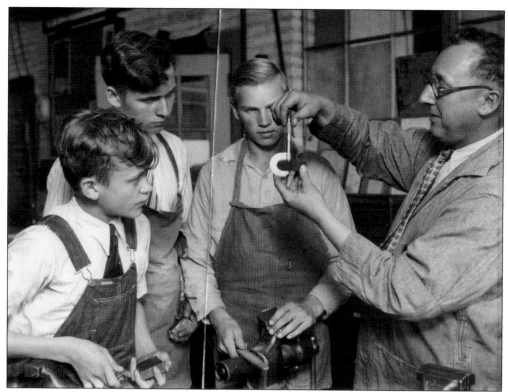

In an industrial arts ("shop") class at Kosciuszko School in the 1940s, students received training for the skilled trades. Here, a student uses a low-tech micrometer to measure thickness, possibly for an engine. Over the decades, manual education was dropped from most curricula when educational leaders argued these classes did not promote intellectual inquiry. (Courtesy of Kosciuszko Montessori School.)

By 2000, there were over a dozen public and private schools on the Old South Side. Gradually, student bodies began to look more like the neighborhood. By the late 20th century, the neighborhood schools served students from a variety of ethnic groups. St. Hyacinth School students pose here with craft projects they created for Catholic School Week. (Courtesy of St. Hyacinth School.)

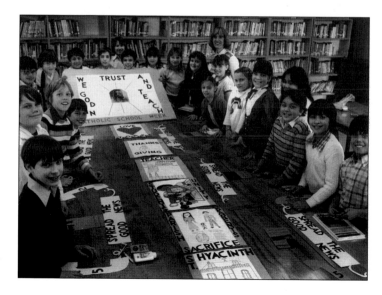

During the Polish era, few government or nonprofit service organizations were available. While churches offered some social services such as food pantries, the Poles also formed fraternal organizations that provided a variety of services, including insurance, settlement assistance, and recreation. Members of the Sons of Polish Pioneers board of directors of 1890–1915 are pictured here. This society was well known for its support of Polish causes. An annual event during the early years was a minstrel show, sometimes performed at the South Side Armory. The shows often

OKAZYI
CY ZAŁOŻENIA
STYNA B.
ZĄD
1915
BYLI PREZESI

included comedy acts that poked fun at public officials, as well as group and individual singing. By 1920, the society had over 200 members, all of whom had to be American citizens with parents who had lived in the United States for more than 25 years. (Courtesy of Kwasniewski Photographs, UWM Libraries, kw000921.)

The largest federation, the Polish National Alliance (PNA), had its own drum and bugle corps (seen here on the Old South Side). Founded in Philadelphia in 1880, the PNA was one of the earliest Polish federations. Like most fraternal organizations, the only requirement for membership was purchase of some kind of insurance policy. (Courtesy of Kwasniewski Photographs, UWM Libraries, kw000853.)

Pictured in 1926 are members of Woodrow Wilson Post No. 11 of the Polish Legion of American Veterans, which was founded by Walter Lewandowski in 1923. The organization was founded to champion American patriotism at a time when the Poles were under pressure to prove they were loyal Americans. (Courtesy of Kwasniewski Photographs, UWM Libraries, kw050001.)

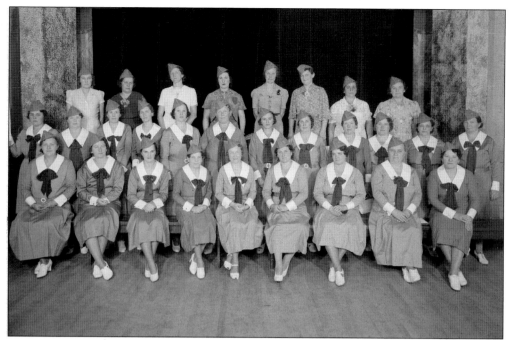

Three years after the Woodrow Wilson Post was established, a Ladies Legion was formed, which changed its name to Auxiliary in 1929. The ladies performed voluntary work for the organization and furthered the goals of Americanism and the welfare of American veterans of Polish descent. Members of the Ladies Legion No. 3 are pictured above. (Courtesy of Kwasniewski Photographs, UWM Libraries, kw000815.)

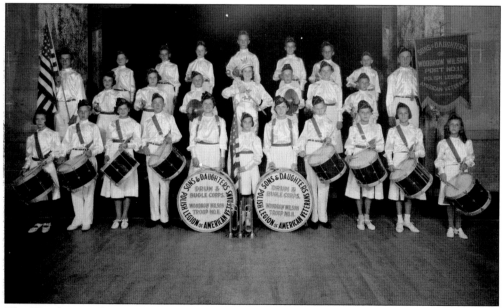

The Woodrow Wilson Post No. 11 also spawned a Sons and Daughters of the Polish Legion of American Veterans. The Drum and Bugles Corps, featuring a color guard, and percussion and brass instruments, is pictured above. They often performed as a parade corps. (Courtesy of Kwasniewski Photographs, UWM Libraries, kw000768.)

By the 21st century, most health and social services on the Old South Side were provided by nonprofit organizations. On the corner of Fifth Place and Lincoln Avenue is the Empowerment Village associated with Our Space Inc. and Cardinal Capital Management Inc. The facility, opened in 2011, serves individuals with mental illnesses. (Courtesy of Urban Anthropology.)

The Old South Side does not have a hospital, but small health clinics are dispersed throughout the neighborhood. Pictured is the Lincoln Health Center at the corner of Sixth Street and Lincoln Avenue. Most of the centers, such as this one, offer bilingual services, and some offer services in multiple languages to accommodate the diversity of the area's population. (Courtesy of Urban Anthropology.)

Once called the Lincoln Avenue Business Men's Association, the club reorganized as the Lincoln Village Business Association in the 1980s. Under its leadership, Lincoln Avenue was honored by being the first street in the city of Milwaukee designated a "Main Street" under Wisconsin's statewide Main Street program in 2002. This is Roman Kwasniewski's membership plaque from 1922. (Courtesy of Barbara Nelson.)

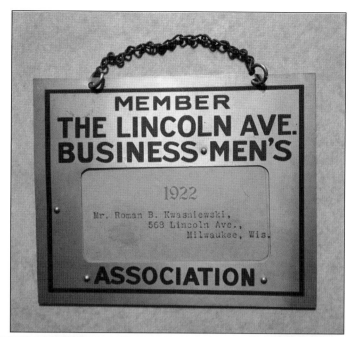

The Lincoln Neighborhood Redevelopment Corp. (LNRC) has provided assistance to businesses on the Old South Side since 1989. The nonprofit was founded by the Lincoln State Bank (later BMO Harris Bank), in compliance with the Community Reinvestment Act—a law designed to encourage banks to give back to the community. (Courtesy of Urban Anthropology.)

The Old South Side Settlement Museum near Seventh Street and Lincoln Avenue is both a museum and a social service organization. The museum houses Urban Anthropology Inc., which serves as the neighborhood association of the Baran Park and Lincoln Village neighborhoods in the heart of the Old South Side. (Courtesy of Urban Anthropology.)

The Old South Side Settlement Museum, opened in 2006, tells the story of the history of the area, from its Polish era through the arrival of 110 national groups in the last half of the 20th century. Rooms replicate the period of the major ethnic groups that settled the neighborhood. The one pictured here is representative of a Polish family in 1929. (Courtesy of Urban Anthropology.)

This kitchen at the Old South Side Settlement Museum heralds the arrival of the first Mexican family to the area in the 1950s. Additional rooms and exhibits highlight the arrival of the Kashubes and the ongoing presence of American Indian groups in the neighborhood. (Courtesy of Urban Anthropology.)

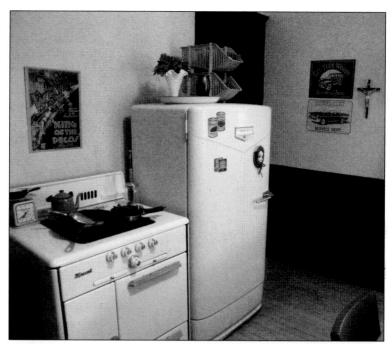

The Kosciuszko Community Center opened in 1982 in Kosciuszko Park. The center offers activities for youth and adults in the area, including a health fitness center, sports clubs, preschool programs, an aquatic center, gym, tennis courts, lagoon fishing, and seasonal youth programs. The walls of the center are adorned with art from the surrounding community. (Courtesy of Urban Anthropology.)

The Old South Side was seldom without a newspaper. A Polish language newspaper, the *Kuryer Polski* (whose float is pictured here in a procession at Kosciuszko Park), was founded by local businessman Michal Kruszka. It published its first edition in June 1888. (Courtesy of Kwasniewski Photographs, UWM Libraries, kw060011.)

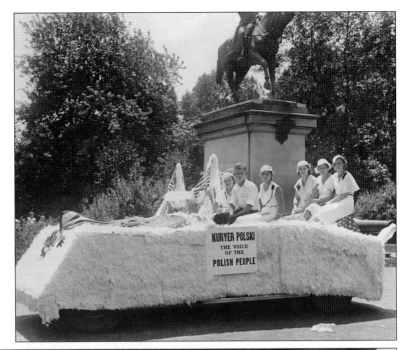

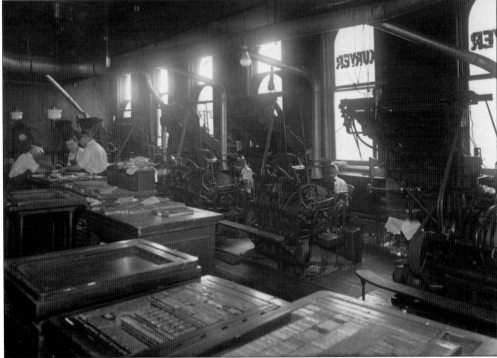

The *Kuryer* grew quickly, with circulation from Canada to South America. While the center of its news was always the Old South Side, by 1908 its Milwaukee circulation was over 70,000 and American circulation over four million. The newspaper's offices, shown here about 1928, had moved from Mitchell Street to downtown Milwaukee. (Courtesy of Kwasniewski Photographs, UWM Libraries, kw000143.)

Some Kuryer articles were printed in both English and Polish—particularly if the article had a more universal or celebrity appeal. In 1929, actress Gilda Gray (née Michalska) visited the Kuryer offices. Born in Poland, she had settled in Milwaukee and was famous in America for popularizing the "shimmy." A Polish patriot, her story was once broadcast on *This Is Your Life*. (Courtesy of Kwasniewski Photographs, UWM Libraries, kw060335.)

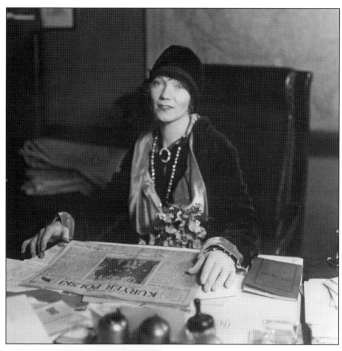

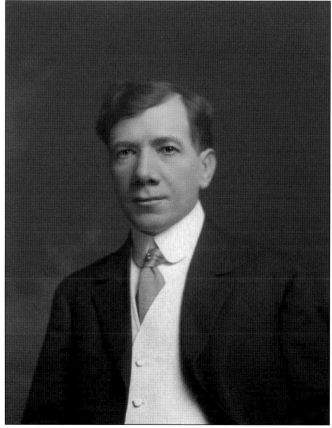

The founder and early editor of the *Kuryer*, Michal Kruszka, was born in Poland in 1860. Later settling on the Old South Side, he took strong stands in editorials on labor and Polish homeland issues. One of his more celebrated battles was over the promotion of Polish priests in the German-dominated archdiocese in Milwaukee. This created a 25-year battle with the local archbishop. (Courtesy of Milwaukee County Historical Society.)

The archbishop of the Milwaukee archdiocese early in the 20th century was S.G. Messmer. He accused the Polish clergy of not being "American enough" for promotion in the Church. When Kruszka's *Kuryer* criticized his stand, he helped create a second Polish language newspaper, the *Nowiny Polskie*, and in 1912 declared that anyone reading the *Kuryer* would be denied sacramental absolution for their sins. (Courtesy of Milwaukee County Historical Society.)

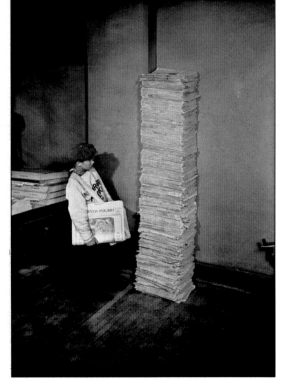

The *Kuryer* eventually lost its readership when Polish was no longer widely spoken in the United States, and closed in 1962. From the 1970s until 1981, a bimonthly English newspaper, the *Southside Urban News*, served the more diverse area. Since then, several bilingual newspapers, including the *Spanish Journal, Aqui,* and *El Conquistador,* serve the area. (Courtesy of Kwasniewski Photographs, UWM Libraries, kw000145.)

Six

GREEN SPACES

Green spaces are critical to the health of people living in urban areas. First, they provide an ecological advantage. Islands of green space promote biodiversity and help residents to understand their place in and effect on nature. Second, green space has a recreational benefit. Without the available parks, the residents of the Old South Side would not have been able to hold major festivals and celebrations or host the many sporting events they have enjoyed over the years. Third, green spaces are aesthetic. The five parks of the Old South Side, the Kinnickinnic River, and the 200-acre Forest Home Cemetery are all picturesque additions to an otherwise highly populated urban area.

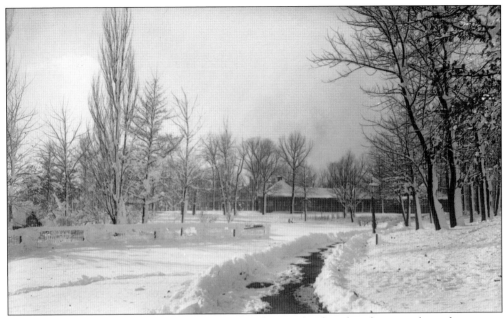

The Old South Side is the most heavily populated area of Milwaukee, but it is also rich in green space. The central park is Kosciuszko, which covers 34.7 acres nestled between Seventh Street (east), Tenth Street (west), Lincoln Avenue (south), and Becher Street (north). The City of Milwaukee began buying the land, called Coleman Tract, from J.C. Coleman in the 1890s. A two-acre lagoon was excavated, and trees and walkways were added. Originally named Lincoln Avenue Park, it was renamed Kosciuszko Park in 1900 after noted general Thaddeus Kosciuszko. Today, the park has a lagoon, community center, playground, tennis courts, and picnic areas. The photograph above shows a snowstorm at the park in 1916. The image below was taken in the late 20th century. (Above, courtesy of Kwasniewski Photographs, UWM Libraries, kw000203.; below, courtesy of Urban Anthropology.)

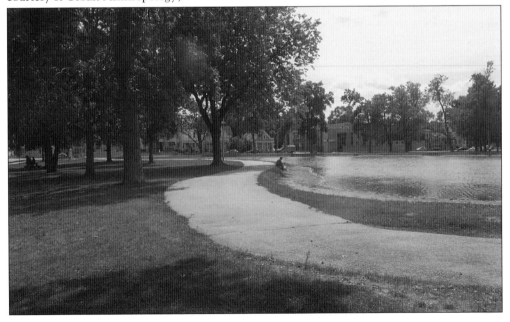

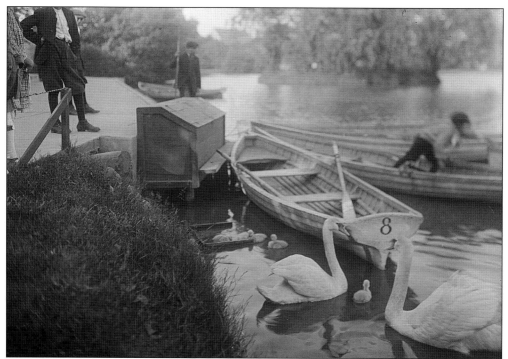

The original pond at Kosciuszko Park was much larger in the earlier 20th century than it is today. During the Polish era, boating on the pond was a common recreational activity. Both row boats and paddleboats were popular choices. Over time, swans were replaced by geese, and the pond was stocked with fish. (Courtesy of Kwasniewski Photographs, UWM Libraries, kw000561.)

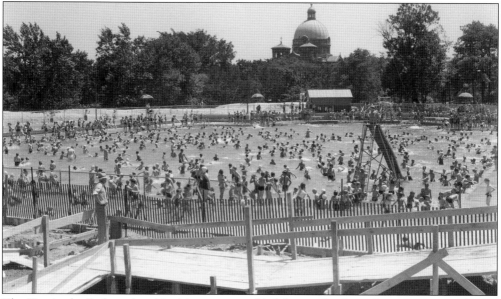

The Kosciuszko Park pool and bathhouse were added during the Great Depression, a product of the Works Progress Administration (WPA). Plans for the project were completed in 1939 and construction for the pool began in 1941. The bathhouse was not completed until 1943. (Courtesy of Milwaukee County Historical Society.)

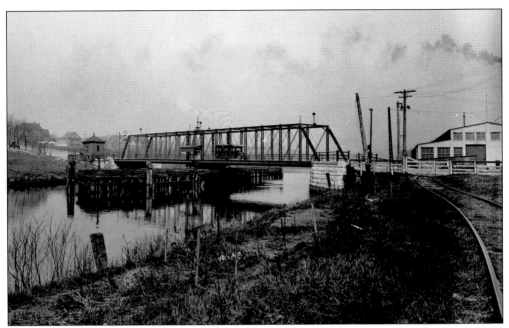

Baran Park was named after Fr. Theodore Baran, the priest who led the effort that paid off the parish debt in 1929 for the construction of the Basilica of St. Josaphat. Baran Park is nestled between Grant Street (north), Third Street (west), First Street (east), and Chase Avenue (south). The park opened in 1950. The top photograph shows the park from the Lincoln Avenue bridge in 1924, which was razed in the middle of the 20th century. The park is especially known for its summer baseball leagues sponsored by the United Community Center. In addition to the baseball diamond, the park has other sports fields, picnic areas, and a playground. (Above, courtesy of Kwasniewski Photographs, UWM Libraries, kw000213; below, courtesy of Urban Anthropology.)

Pulaski Park, named after Revolutionary War hero Casimir Pulaski, is nestled between Windlake Avenue (north), Eighteenth Street (west), Sixteenth Street (east), and Cleveland Avenue (south). The original park was purchased in 1910, and altered in 1919 and 1924. Sitting on 25.9 acres by 2012, the park has an indoor swimming pool, tennis court, wading pool, tot lot, basketball court, and lighted sledding hills. (Courtesy of Urban Anthropology.)

Modrzejewski Park is located between Tenth and Eleventh Streets along Cleveland Avenue. The park was named in honor of a local military hero, Polish American Robert Modrzejewski. He was a recipient of America's highest military decoration, the Medal of Honor, for risking his life above and beyond the call of duty in Vietnam. The park features a playground, basketball court, and softball/baseball diamond. (Courtesy of Urban Anthropology.)

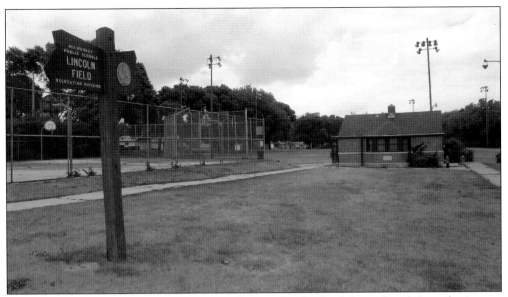

Lincoln Field Park is located between Second Street (east), Third Street (west), Lincoln Avenue (south), and Grant Street (north). It provides a scenic hilltop view of the Kinnickinnic River on its northeastern boundary. The park features a tennis court, picnic areas, and a basketball court. (Courtesy of Urban Anthropology.)

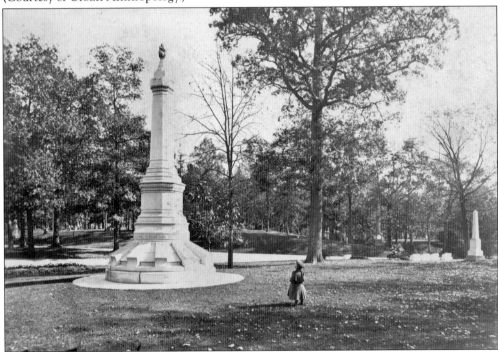

Forest Home Cemetery sits on 200 acres between Cleveland Avenue (north), Lincoln Avenue (south), Twenty-seventh Street (west), and Twentieth Street (east). Established in 1850, the cemetery is listed in the National Register of Historic Places. The grounds are so picturesque that the early Polish settlers picnicked there on Sundays before the park system was developed. (Courtesy of Milwaukee County Historical Society.)

On the grounds of the Forest Home Cemetery are the beautiful Chapel Gardens, Landmark Chapel, and the Hall of History that tells the story of Milwaukee dignitaries who are buried at Forest Home. This includes the European founders of Milwaukee, several mayors, major African American activists, and brewery tycoons. (Courtesy of Urban Anthropology.)

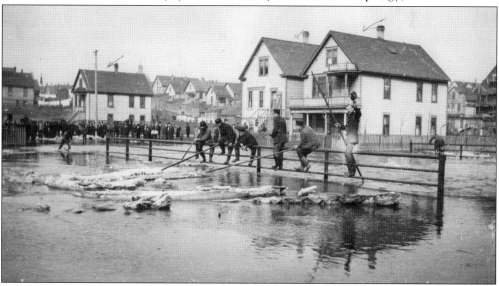

The Kinnickinnic River runs east to west near the northern boundary of the Old South Side. The name comes from a plant named kinnickinnic (or bearberry) that grows in northern climates. The leaves of the kinnickinnic were prized by North American Indians for their healing properties. This photograph was taken in 1912 when the river flooded its banks. (Courtesy of Kwasniewski Photographs, UWM Libraries, kw000225.)

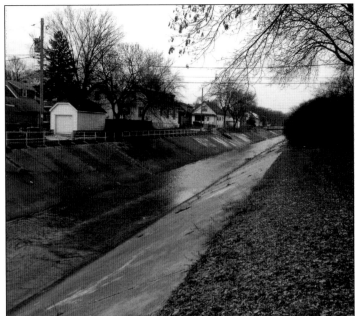

The Kinnickinnic River is 9.6 miles long with a watershed that covers 25 square miles of drainage area. In the 1960s, concrete walls were installed along a major section of the river boundaries to minimize the flooding that was having devastating effects on the neighborhoods of the Old South Side. (Courtesy of Urban Anthropology.)

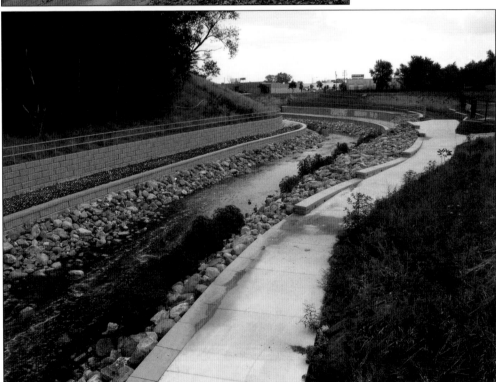

In 2002, the Milwaukee Metropolitan Sewage District (MMSD) and several other local organizations began a planning process to remove the concrete walls along the Kinnickinnic River. In the years that followed, the river was restored to a more natural state. The new channel alignment slowed stream velocity and accommodated excessive rainwater. Accessible green space was developed on the river's boundaries. (Courtesy of Urban Anthropology.)

Seven

ARCHITECTURE AND MONUMENTS

The Old South Side has unique architecture. The early Polish population brought the architectural tradition of the building parapet with them from northern Poland. The Flemish architects were among the first to use parapets, but this feature spread through Europe quickly. A decree of the Krakow Municipal Council of 1544 stated that walls should be built around the roofs of new buildings as fire prevention. From here on out parapets were a common feature in Krakow but did not spread throughout the country for many years. Gdansk, Poland, where many of the Old South Side Polish immigrants once lived, has a strong parapet influence. The parapets adorn commercial buildings along Lincoln Avenue and other blocks.

The importance of statuary and public art to the Old South Side cannot be overstated. The ethnic element is evident from the earliest monument to the youth art pillars created over 100 years later to tell the cultural history of the area. Of particular importance is the Kosciuszko Monument. In 1905, Milwaukee's Polish community dedicated a bronze equestrian statue of Thaddeus Kosciuszko in Kosciuszko Park. Kosciuszko, a hero of Poland's struggle for national independence, had also helped the American colonies win freedom from Great Britain in the Revolutionary War. The base of the monument was inscribed "To the Hero of Both Hemispheres." The seven-ton bronze by Italian sculptor Gaetano Trentanove was the first equestrian statue to be erected in the city—a significant achievement for Milwaukee Poles. In 1951, the monument was relocated from the northern part of the park to the southern edge, closer to Lincoln Avenue. As a prominent symbol of the Polish presence in America, the Kosciuszko Monument has been a focal point for important celebrations and political events over the years.

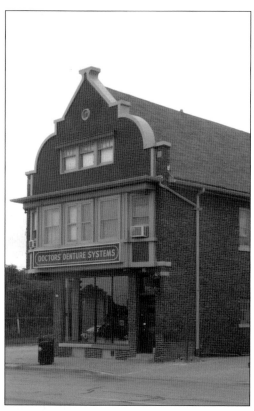

A distinctive feature along Lincoln Avenue on the Old South Side (as seen here on Fifth Street and Lincoln Avenue) is the building parapet (the adornment above the roofs of commercial establishments). The Poles brought this architectural style from the northern section of their homeland, especially Gdansk. (Courtesy of Urban Anthropology.)

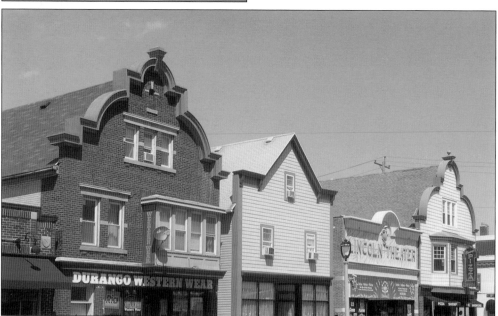

This photograph shows the parapet theme across several buildings on Lincoln Avenue. Today, parapets still adorn Lincoln Avenue commercial buildings. The organizations on the Old South Side work to enforce this architectural element on new development projects to ensure that the building style harmonizes with others on the street. (Courtesy of Urban Anthropology.)

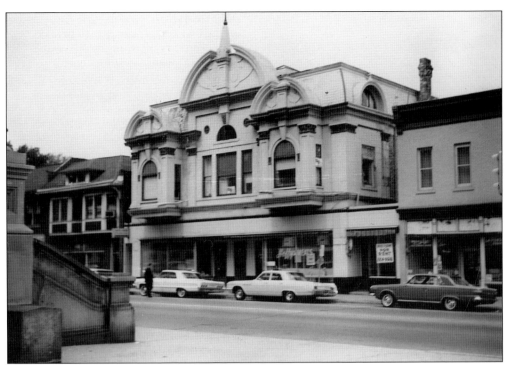

Another architectural influence was inspired by the Basilica of St. Josaphat. Probably to offset the debt incurred by the construction of the basilica, the same architect, Erhard Brielmaier, was commissioned to design the Grutza-Leszczynski Building as a commercial property, directly across the street from St. Josaphat's. The building featured large rounded broken pediments that would complement the basilica. (Courtesy of Historic Photo Collection/Milwaukee Public Library.)

Unlike the architecture of commercial properties, the building style of homes generally followed the pattern of American workers' homes from the late 19th century, with no evidence of folk influences or construction methods from Poland. Builders employed industrial building processes typical of American houses of the time. Pictured is a typical home built during early Polish settlement of the Old South Side. (Courtesy of Kwasniewski Photographs, UWM Libraries, kw000275.)

While the Poles did not follow folk customs in home building, they did add their own touch—known as the "Polish flat" building form. When the Poles arrived, they purchased narrow lots for cottages. As their families grew, it was hard to add rooms because the lots were too narrow. So they lifted the foundations, added cement blocks or bricks, and created semi-basement levels that became new dwellings. (Courtesy of Urban Anthropology.)

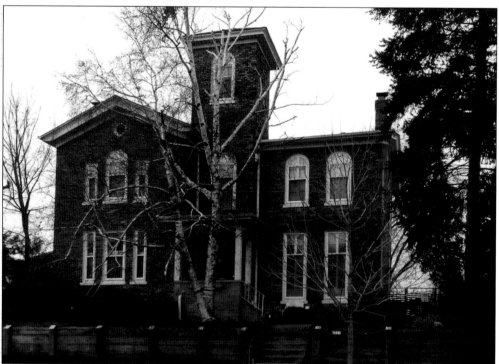

The Kunckell House on Sixteenth Street is one of the oldest homes on the Old South Side. Built in the Italianate style out of locally produced cream city bricks, the house predates the workman's cottages and Polish flats distinctive of the neighborhood. A German family originally owned it and operated a soda pop factory from a log cabin that was once on the property. (Courtesy of Urban Anthropology.)

In 1955, the Milwaukee County Expressway Commission planned a 49-mile, $367-million network of highways for the increasing numbers of automobiles on the roads. One of these highways was Interstate 43, which ran south from downtown to the airport. This construction removed hundreds of homes along Fourth Street, creating a housing shortage by the 1970s, resulting in many Poles moving away from the Old South Side. (Courtesy of Urban Anthropology.)

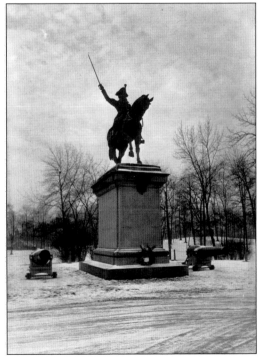

Statuary helped define the area. The Thaddeus Kosciuszko Monument, located in Kosciuszko Park, was sculpted by Gaetano Trentanove. Milwaukee's Polish community presented the monument to the city of Milwaukee in 1905. Standing originally at the north end of the park, it was moved to a location near Lincoln Avenue in 1951. A restoration effort began in 2006 under the Polish organization Polanki. (Courtesy of Kwasniewski Photographs, UWM Libraries, kw000202.)

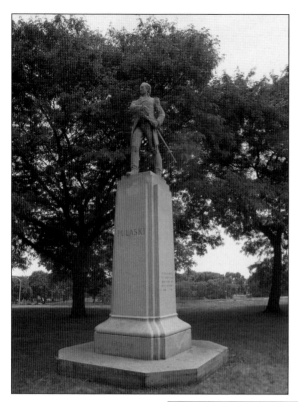

The cast bronze statue of Casimir Pulaski is located in Pulaski Park, at the intersection of Harrison Avenue, Sixteenth Street, and Windlake Avenue. Polish-born Pulaski was most known in America for saving the life of George Washington during the Revolutionary War. The sculptor was Joseph Kiselewski. The statue was dedicated on October 18, 1931. (Courtesy of Urban Anthropology.)

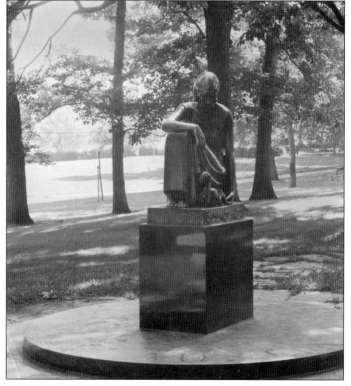

Probably the biggest mystery ever on the Old South Side was the disappearance of the *Memorial for Belle Austin Jacobs* (sculpted by Sylvia Shaw Judson), affectionately called the "squirrel lady" or "peanut lady" by locals. Jacobs was the founder of the University Settlement Club and worked with the early arriving Polish community. She died in 1929. (Courtesy of Historic Photo Collection/ Milwaukee Public Library.)

On the morning of December 16, 1975, the staff at Kosciuszko Park arrived early for work and noticed something. The "squirrel lady" was gone. Thieves had come in the middle of the night and somehow removed the statue. An investigation followed and revealed no leads. This is one of the last known photographs of this statue, taken about 1970. The man is Val Figueroa. (Courtesy of Nick Figueroa.)

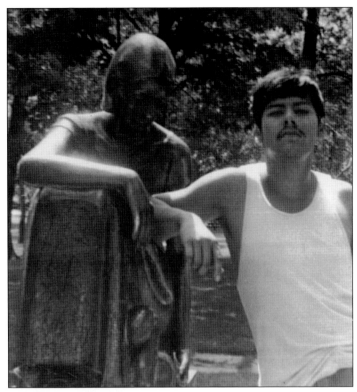

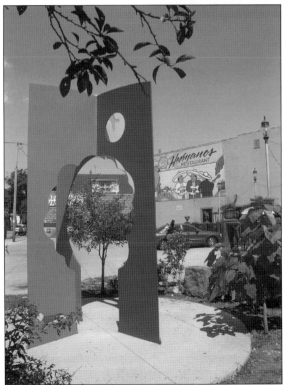

In 2008, new public art was added at the corner of Windlake and Lincoln Avenues at Club Tres Hermanos. Called *Quartet*, the artwork depicts four seasons as metaphors for the Old South Side. Each ethnic group adds a unique voice to the consolidated whole. The artist is Celine Farrell. Another similar piece by the same artist, called *Le Colorres*, is three blocks east. (Courtesy of Urban Anthropology.)

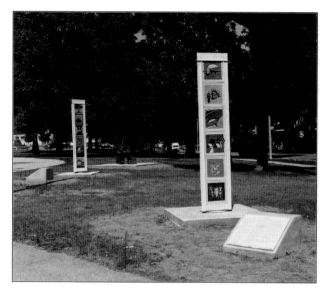

Between 2009 and 2011, area youth worked with Urban Anthropology to create two pillars on the cultural history of the Old South Side's largest ethnic communities, at Kosciuszko Park. Each pillar has three sides with six tiles. Each side tells the story of one of the following groups in this neighborhood: the American Indians, Poles, Mexicans, Puerto Ricans, Germans, and African Americans. (Courtesy of Urban Anthropology.)

Designed by local Mexican artist Juan Flores, the *Native Couple* bench at Kosciuszko Park was dedicated in 2011. The bench signifies the ubiquitous and beneficial presence of the American Indians on the Old South Side, from prehistoric times to the present. The bench is located near Seventh Street and Lincoln Avenue. (Courtesy of Urban Anthropology.)

Eight

ETHNIC MARKERS

The ubiquitous use of ethnic markers on home and building facades or in front yards is a relatively recent phenomenon. Before the widespread acceptance of multiculturalism in the 1990s, ethnic markers of any kind were considered a source of embarrassment in America. Writings of scholars from Colonial times to the 1960s stressed assimilation. Social scientists ranked immigrant groups by the speed with which they lost the languages and practices of their former homelands. The assumption was that those who were slower to lose their markers were inferior.

Milwaukee has always been somewhat more accepting of ethnicity. Perhaps because this city had been organized chiefly by Germans rather than Yankees, there was more tolerance. Few objected when the inauguration speech of Milwaukee's first mayor, Solomon Juneau, was printed in both English and German. The Poles of the Old South Side, who considered "Polishness" a sign of status, were especially eager to retain their ethnicity. However, while Milwaukeeans might have been more accepting of European markers, they were conversely just as slow to welcome populations of Asian, African, or Latin American ancestry as citizens elsewhere.

As attitudes across America changed in the 1990s, residents on the Old South Side responded. They were particularly eager to display ethnic markers. The markers portrayed on the following pages were highly visible statements of the times.

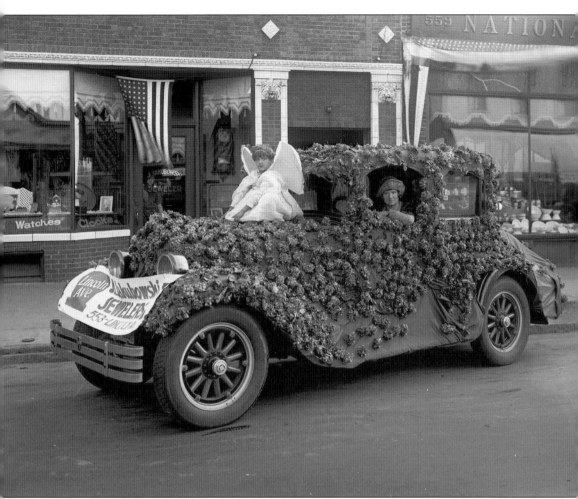

Before the 1990s, ethnic groups experienced pressure to assimilate. This was the age of the melting pot, in which cultural differences were expected to disappear into an Anglo American standard. The local Poles resisted assimilation more than most. Few homes were lacking Polish imagery such as the flag of Poland, the Polish eagle, or Our Lady of Czestochowa, a depiction of the Madonna that was intimately associated with Poland for over 600 years. While maintaining one's "Polishness" was crucial for local community life, Poles also faced pressure by outsiders to demonstrate their allegiance to America. For this reason, many Poles and a large proportion of businesses on the Old South Side mounted the American flag from building facades in a very visible manner. The flag is seen here on the facade of the Riviera Theater. (Courtesy of Kwasniewski Photographs, UWM Libraries, kw000001.)

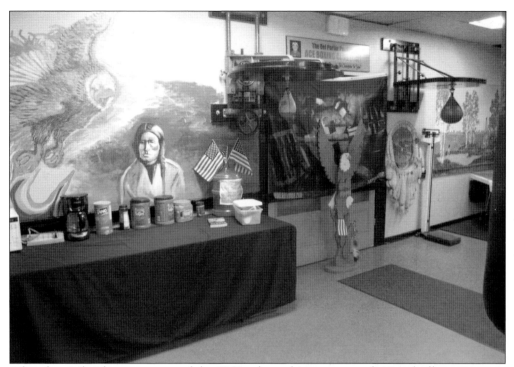

After the civil rights movement of the 1960s, the melting pot metaphor gradually gave way to the "salad bowl," suggesting that it was now desirable for different ingredients in a population to retain their own flavors. Since the 1990s, residents of the Old South Side began displaying their ethnic markers alongside the American ones, as exemplified by the wall decor at Ace Boxing. (Courtesy of Urban Anthropology.)

Many homes today openly display flags of their past homelands. Here, a Mexican family shows their pride in their flag on Tenth Street. While inter-ethnic metaphors may have shifted from a melting pot to a salad bowl, the most common flag seen flying on the Old South Side is still the American flag. (Courtesy of Urban Anthropology.)

By the 1980s, it was common to see the Virgin of Guadalupe and Our Lady of Czestochowa displayed as yard art. The Virgin of Guadalupe (pictured) is upheld as a miraculous depiction of the Madonna to an indigenous Mexican, and parallels Our Lady of Czestochowa, whose representation bore witness against a Hussite attack in Medieval Poland. (Courtesy of Urban Anthropology.)

The Cyrillic inscription on the awning of the Old Town Serbian Gourmet House testifies to the Serbian presence on the Old South Side. Serbian linguist Vuk Karadzic standardized the Serbian Cyrillic alphabet in 1818 by following the strict phonemic principles of the German model and Jan Hus's Czech alphabet. In 1971, Alex Radicevich opened the restaurant at Fifth Place and Lincoln Avenue. (Courtesy of Urban Anthropology.)

Nine

BUSINESSES OVER THE GENERATIONS

Lincoln Avenue on the Old South Side has had a long history of successful mom-and-pop establishments. The cornerstone businesses have always been the Rozga Funeral Home and Ben's Bicycle Shop, later renamed Ben's Bicycle and Fitness. Beginning at the end of the 19th century, the Poles created a self-sufficient business district designed to serve residents' daily needs. Businesses included grocers, financial institutions, beauty shops, butchers, pharmacies, fruit markets, restaurants, clothing stores, bakeries, shoe stores, real estate agencies, ice cream shops, taverns, theaters, garages, hardware stores, funeral homes, and a brewery.

When the Mexicans began migrating into the neighborhood in large numbers in the 1970s, they were slow to set up shops. Most frequented businesses run by Latinos some blocks north of the Old South Side. This began to change in the late 1990s, and today nearly half of the businesses on the Old South Side are run by Latinos.

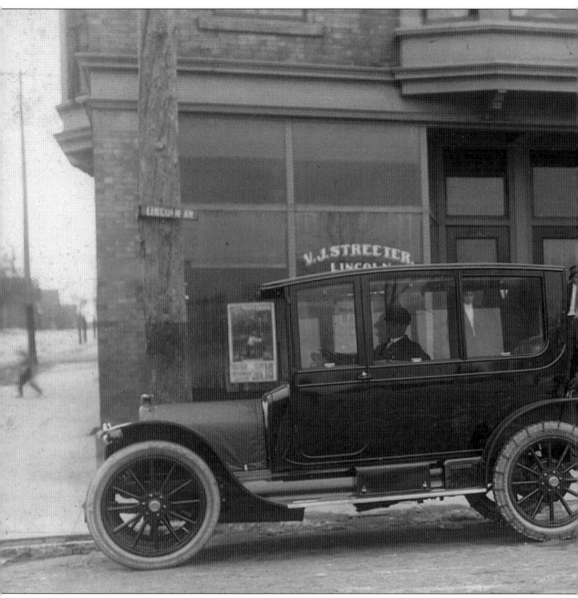

Two businesses that were established during the Polish era have acted as cornerstones for the Old South Side on Lincoln Avenue. One of these was the Rozga Funeral Home that opened in 1898, pictured about 1930. The other was Ben's Bicycle Shop, shown on succeeding pages. The funeral home did not always occupy the entire building at Seventh Street and Lincoln Avenue. During the Great Depression, the lower level was shared with the Streeter Billiards Parlor. The house to

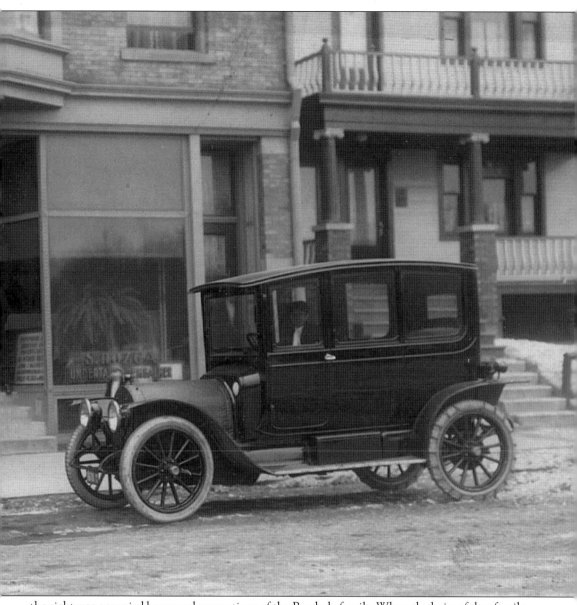

the right was occupied by several generations of the Brzakala family. When the heirs of that family died, the Rozga family purchased the home. The family waited years to lease the place to an entity that they believed would add value to Lincoln Avenue. In 2006, the building was remodeled and became the Old South Side Settlement Museum. (Courtesy of the Rozga family.)

The Rozga Funeral Home passed through the same lineage from 1898 into the 21st century. By 2010, four generations of Rozgas had operated the establishment. The funeral home enjoyed a neighborhood-friendly reputation beginning with the Great Depression. When residents were unemployed or facing loss of their homes, the proprietors made a decision to provide funerals for residents free of charge. Thomas Rozga, who grew up living above the funeral home during the Depression, was once asked what it was like to do without during that time. He replied that his father told the children it was their family's mission to serve the neighborhood, and "perhaps this was the reason we are here." The free funerals continued for almost a decade and residents talked about it well into the 21st century. Today, the Rozga family still supports most community efforts. (Courtesy of Urban Anthropology.)

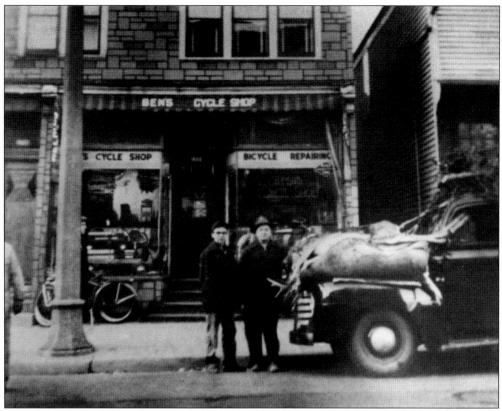

Another cornerstone business was the bicycle store. In 1928, Ben Hanoski, one of the Polish families that had settled on the Old South Side, opened Ben's Bicycle Shop, later renamed Ben's Cycle and Fitness. Above, Ben Hanoski and his 15-year-old son Larry pose with their 1946 Ford pickup truck in front of the original location at Tenth Street and Lincoln Avenue. (Courtesy of the Hanoski family.)

In 1999, the Hanoski family, then run by Vince Hanoski, expanded Ben's Cycle and Fitness from one small storefront on the north side of Lincoln Avenue to a second building that once housed the Riviera Theater, on the south side of the street. This expansion gave the business the warehouse space it needed to expand into Internet sales. (Courtesy of Urban Anthropology.)

Ben's Cycle and Fitness expanded again in 2009 into an adjacent building. In 2012, the business added a new department called Rowerowa Szkola, or "Bicycle Shop" in Polish. The neighborhood-inspired new program teaches cyclists to fix their own bikes while they share information with other cyclists. The program hearkens back to the Gay Nineties on the Old South Side when there were several nearby bicycle clubs—Mercury Cycling Club, South Side Cycling Club, Morgan and Wright Club, and Sterling Club. Bicycles built for one or two back then had several limitations, including bad roads, delinquents sticking pins in the pneumatic tires, and women's bloomers. The bloomers, or baggy slacks, were considered scandalous by many, including some of the Poles. Even so, women wore them while competing in neighborhood bicycle races. (Courtesy of Urban Anthropology.)

Lincoln Avenue began developing in the late 19th century. In 1890, Fred Herrenbruch opened a hardware store at the corner of what is today Sixth Street and Lincoln Avenue. The building was completed in 1898. His son Emil took over the business in 1921. The commercial property remained almost exclusively a hardware store into the 21st century. (Courtesy of Urban Anthropology.)

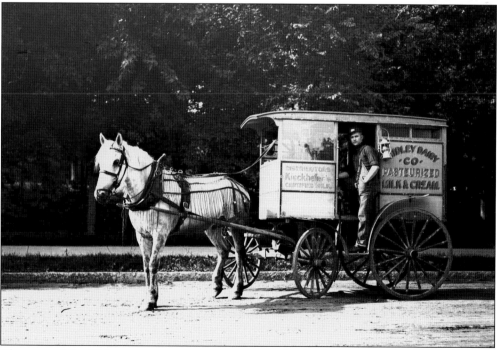

The turn of the 20th century was a prosperous time for development on the Old South Side. Several establishments were already operating on Lincoln Avenue, and the Basilica of St. Josaphat was under construction. The milkman used "horsepower" to deliver dairy products. Here, a horse named Casper delivers milk in a wagon owned by Gridley Dairy in 1910. (Courtesy of Kwasniewski Photographs, UWM Libraries, kw000188.)

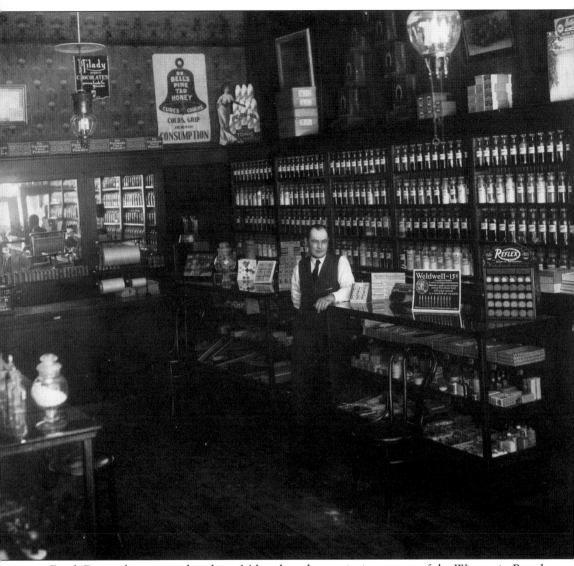

Frank Drozniakiewicz was listed as a Milwaukee pharmacist in a report of the Wisconsin Board of Pharmacy in 1903. His pharmacy, pictured here, was located on Lincoln Avenue. Pharmacies before the Civil War period lacked scientific method. It was around the 1860s when the drugstore moved from alchemy and conjecture to a more scientifically based institution. In the early 20th century, it was common for a pharmacist to receive most training through apprenticeships in other pharmacies. However, the inconsistent nature of this training was a factor in creating the Board of Pharmacy, which standardized training. Not visible in this interior view of the Drozniakiewicz Pharmacy, soda fountains and sandwich counters were being introduced in drugstores at this time. They did not become truly popular until the 1920s, perhaps filling a void created when the bars closed during Prohibition. (Courtesy of Kwasniewski Photographs, UWM Libraries, kw000155.)

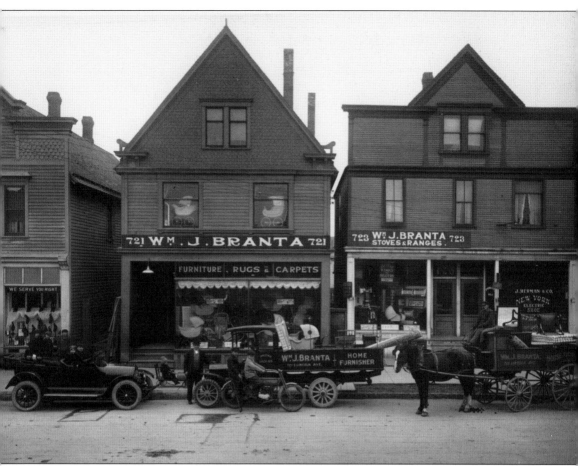

As it does today, Lincoln Avenue in the early 1900s hosted an amalgam of independently owned, locally run stores. William J. Branta's Home Furnishings Company was located on Lincoln Avenue, west of Windlake Avenue. "The only Polish furniture store on Lincoln Avenue," according to its slogan, Branta's Home Furnishings was established shortly after the turn of the century. This followed the closing of the original Rozga Furniture Store on Lincoln Avenue when the Rozga family moved into the mortuary business. Home furnishings were evolving during the early 1900s. Some of the popular new furnishings of the day included smoking stands, tea carts, blanket chests, and rolling chairs, especially if they were made of wicker. Branta also owned the Appliance Store next door, featuring stoves, iceboxes, and washing machines. Neither store survived the Great Depression, and closed shortly after 1930. During this time, furniture and appliance stores were also moving from mom-and-pop ownership to larger companies specializing in mass production. (Courtesy of Kwasniewski Photographs, UWM Libraries, kw000256.)

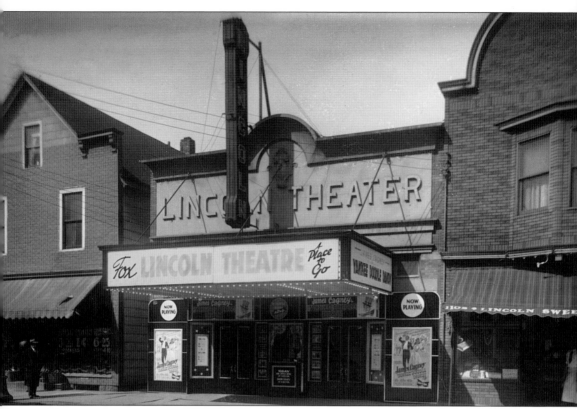

The Lincoln Theater, built in 1910 and seen here in 1917, was a forerunner in developing the "photoplay parlor," which succeeded the Nickelodeon in movie exhibition. The original theater, with its relatively unadorned facade, had pressed tin ceilings and wainscoting, radiator heating, a shallow platform stage without wings, and a player piano rather than a pipe organ. It also had an unusual L-shaped auditorium. It sat 540 people. Longtime residents of the Old South Side talked about the theater having a slot next to the box office where people could drop in notes suggesting future films. After several reincarnations, the projectors eventually stopped in 1966. The building still stands in the 21st century, having been a portrait studio, a chimney warehouse, a Mexican cultural center, and a Mexican candy store. (Courtesy of Kwasniewski Photographs, UWM Libraries, kw000113.)

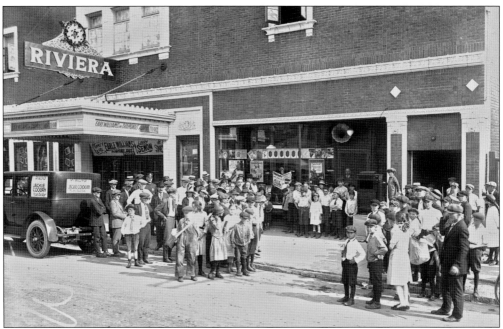

By 1920, the Old South Side had another theater, the Riviera, on Tenth Street and Lincoln Avenue—almost directly across the street from the Lincoln Theater. This venue marked the transition from the "photoplay parlor" to the "movie palace" era. The Riviera had upholstered seats, carpeted aisles, a 39-foot stage, Ionic columns, and a stadium-style balcony. Along with space for neighborhood vaudeville, there was a permanent inner stage set that framed the 15-foot-wide movie screen (typical of the day) on the 39-foot-wide stage. The building later served as a warehouse for Ben's Cycle and Fitness. (Both, courtesy of Kwasniewski Photographs, UWM Libraries, kw000123 (above) and kw000656 (below).)

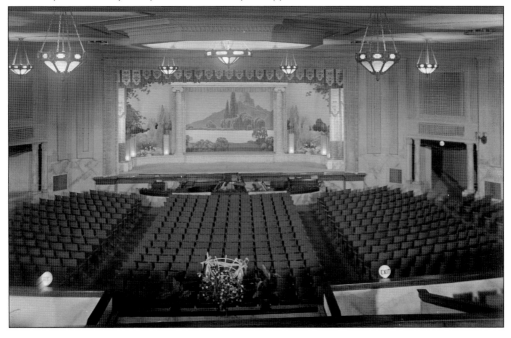

The Lincoln Avenue Loan and Building Association stimulated the fast development of the Old South Side early in the 20th century. Building and loan associations were organizations with cooperative purposes—the object being to provide a relatively secure way for individuals to accumulate savings while having the opportunity to secure money at reasonable interest rates, mainly to build homes. Confining their business to specific neighborhoods, there were several Polish-run building-and-loan associations in Milwaukee in the early 20th century serving mainly working-class individuals. One was the Lincoln Avenue Loan and Building Association. Incorporated in 1910 (pictured in 1920), its major thrust was mortgage loans. According to its financial records of 1915, the Lincoln Avenue Loan and Building Association reported assets just under $120,000, and over $113,000 were receipts from mortgage loans. (Courtesy of Kwasniewski Photographs, UWM Libraries, kw000094.)

Before the advent of the supermarket or department store, residents on the Old South Side might shop at five different stores in order to prepare a meal, including a butcher, dry goods store, fruit market, dairy wagon, and vegetable stand. However, advancements in technology were making food preparation and storage easier. The introduction of refrigerators meant that fewer trips to the market were necessary, as well as longer storage of perishable foodstuffs. Information on vitamins was circulating, and people were becoming more conscious of the value of fruits and vegetables. The Lincoln Fruit Store, pictured on Lincoln Avenue in the early 1920s, was probably a regular stop for the family cook. The motto of the Lincoln Fruit Store was "Our quality is high; our prices are low; our service the best." (Courtesy of Kwasniewski Photographs, UWM Libraries, kw001307.)

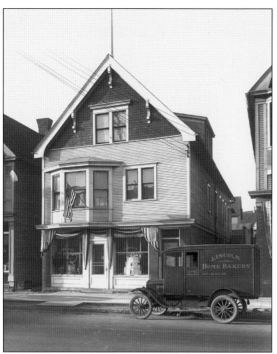

The Lincoln Home Bakery, pictured here on Lincoln Avenue in 1922, was probably another stop made by the family cook. The bakery was owned by the Polish Jazwiecki brothers. Polish American bakeries were particularly busy on "fat Tuesday" before Lent, when they sold special donuts called *paczki*, made from yeast dough and fillings, for indulgence before the fast. (Courtesy of Kwasniewski Photographs, UWM Libraries, kw000096.)

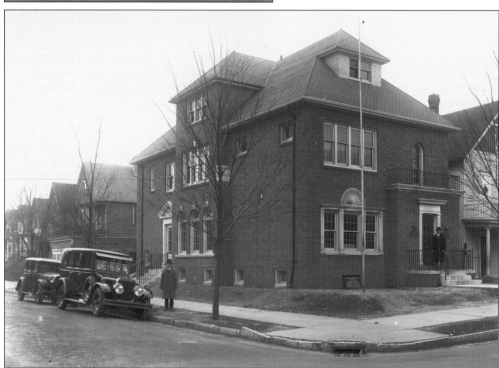

The Rozga men were not the only funeral directors on the Old South Side in the early 20th century. Anton Rosolek Jr. was also a licensed embalmer and funeral director. With his father, he ran the Anton Rosolek and Son Funeral Home on Fourteenth and Hayes Streets, pictured in 1928. (Courtesy of Kwasniewski Photographs, UWM Libraries, kw000053.)

The use of the automobile would forever change life on the Old South Side. By the middle of the 20th century, Lincoln Avenue would become one of the busiest streets in Milwaukee. Bay View Nash, shown in 1925, was an early auto dealer on Lincoln Avenue. Later known as South Side Nash, the dealership would remain at this location through the 1930s. (Courtesy of Kwasniewski Photographs, UWM Libraries, kw000166.)

Store windows were always competitive on the Old South Side. Joseph Wnentkowski had two shoe stores/booteries on the same block on Lincoln Avenue by the 1920s (one shown here about 1925). He was in business with his sons, Walter, Harry, and Max Wnentkowski. The Wnentkowskis also had a shoe store on Milwaukee's north side. (Courtesy of Kwasniewski Photographs, UWM Libraries, kw000165.)

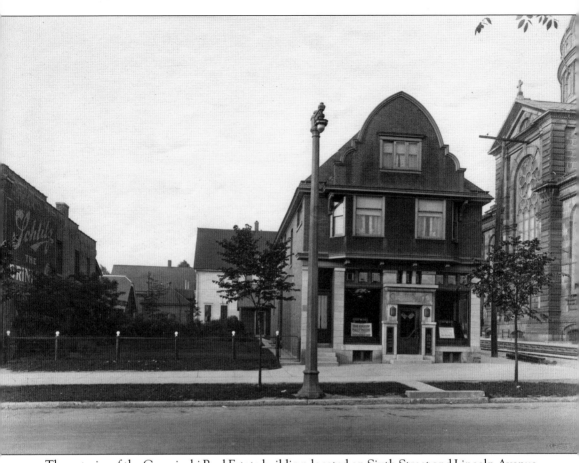

The exterior of the Czerwinski Real Estate building, located on Sixth Street and Lincoln Avenue, has changed little from the time of the Great Depression. During the 1930s, some businesses still thrived despite the economic times. Across the street from Czerwinski's was the majestic Basilica of St. Josaphat. Walking south on Sixth Street, the local resident would pass a penny candy store, Sukaleck's Butcher, and the Superette Grocery Store. On the west side of the street was Pycienski's Drugstore, and Bronk's Tavern with its popular fish fry. Continuing down Sixth Street the resident would pass Weinkel's Pharmacy with ice cream cones for 5¢, Wyucki's Tavern with fish fries for 15¢, Red's Barber Shop, a dry goods store, and a shoe store run by the Zaks. The Zaks held card parties for the ladies every day between 1:00 and 3:00 p.m. (Courtesy of Kwasniewski Photographs, UWM Libraries, kw000027.)

The Old South Side had its own brewery on Thirteenth Street, the Independent Milwaukee Brewery. It was locally known by its brand name, Braumeister. The Brewery opened in 1902, was bought by the G. Heilemann Brewery in the 1940s, and continued (except during the Depression) until 1964. One of its affiliates was Brewery Stache's Tavern, shown here in 1940 on Seventeenth Street. (Courtesy of Kwasniewski Photographs, UWM Libraries, kw000162.)

In 1944, the Ray Hunn Garage was located near Fourteenth and Becher Streets. It continued into the late 20th century, and did full auto repairs and some bodywork. At one time, the corner also housed a gas station pagoda, probably associated with Wadham's Oil and Grease Company of Milwaukee. (Courtesy of Kwasniewski Photographs, UWM Libraries, kw000178.)

The Lincoln State Bank, today BMO Harris, is located on Thirteenth Street (staff shown at a training about 1940). The Old South Side's Gapinski family had an integral involvement with the bank. Max Gapinski served as director and chairman for over 50 years and Michael Gapinski was the first director of the bank's generated nonprofit, Lincoln Neighborhood Redevelopment Corp. (Courtesy of Kwasniewski Photographs, UWM Libraries, kw001309.)

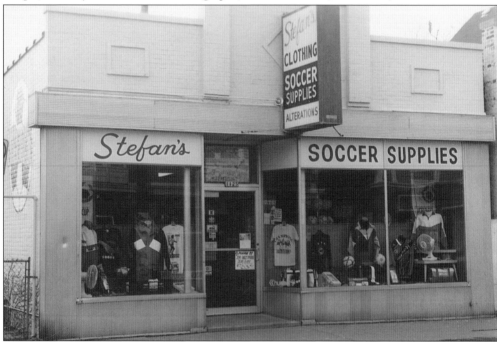

Stefan's Soccer Shop, shown in the 1970s, was once a men's apparel store and tailoring shop. Owned by the Polish Nowakowski family since 1965, the shop became a soccer outfitter in the 1970s when local ethnic players had nowhere else to buy equipment. The family used to live in the back, but they remodeled it so that the entire level is now the soccer store. (Courtesy of the Nowakowski family.)

The first Mexican American family purchased a home on the Old South Side in the 1950s. By the late 1960s, a Mexican-run grocery store appeared. The store, owned by the Gonzales family, was on the southwest corner of Seventh Street and Harrison Avenue. That same family lived on the southeast corner of Seventh and Becher Streets until the early 1990s. (Courtesy of Urban Anthropology.)

Founded by Amil Naegele in 1923, the Naegele Awning Company did not move to its current location on Lincoln Avenue until 1977, when it was purchased by the Hodges family. The Hodges decided to keep the business under the Naegele name because of the reputation of the company. Naegele expanded into a second building next door as business increased. (Courtesy of Urban Anthropology.)

A bait shop operated across from Kosciuszko Park since the 1950s, in part to serve the fishing sport on the park's pond. Owned by the Reinke family in the 1950s, Ken and Mike Biskupski purchased the shop in 1977 and named it Ken & Mike's Bait Shop. However, a disagreement between the brothers left Ken in charge and he renamed it Joe's Bait Shop. (Courtesy of Urban Anthropology.)

By the late 1990s, more businesses owned by Latinos were opening on the Old South Side. Morelia's Market opened in 1997 on Sixth Street. The store featured Mexican specialty items such as bins of spices and dried peppers, chorizo sausages, and their own homemade salsa. Since the turn of the 21st century, over 50 Latino businesses have opened on the Old South Side. (Courtesy of Urban Anthropology.)

Ten

SPECIALTIES AND RESTAURANTS

Specialty shops have had a consistent presence on the Old South Side. This chapter takes a then-and-now approach to florists, delis, boutiques, candy stores, beauty shops, and photography businesses and compares them during the early Polish years to the multicultural period of the 21st century. While these businesses vary by both historical periods and ethnicity of owners, they also had similarities—most notably the ways they met the needs of the residents.

The chapter also looks at the restaurants over the years. Restaurants of many ethnic groups are featured—all offering different cuisines. However, historical eras such as the Great Depression also played strong roles in diversifying the menus.

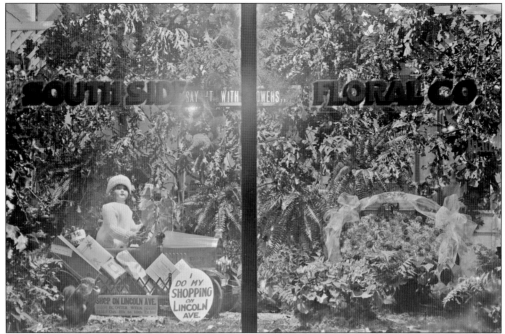

The movement to "shop local" is not a new idea. Note the window sign at T. Lad Gawin's Flower Shop in October of 1931, at the height of the Great Depression. The early 21st century ushered in a resurgent commitment to supporting locally grown, produced, and sold materials on the Old South Side and the city as a whole. (Courtesy of Kwasniewski Photographs, UWM Libraries, kw001304.)

Chet and Leona's Floral Shop has been owned by the Gruettner family since 1950 when it opened on Twelfth Street and Lincoln Avenue. When Jim Gruettner was asked in the 1990s if the neighborhood was dangerous, he recounted how teens of the Lincoln Avenue and the Eighteenth Street gangs fought each other with lead pipes, chains, and brass knuckles—but that was in the 1940s. (Courtesy of Urban Anthropology.)

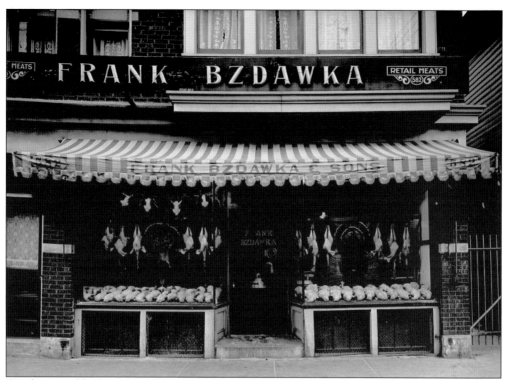

On the same block as Naegele Awning Co. on Lincoln Avenue, Frank Bzdawka's Butcher Shop once thrived. During the Polish era, residents could stop in and order a "fresh" chicken. The owner would go in the back and deliver a live chicken on a leash for the shopper. The shopper would then "walk" the chicken home and prepare it for dinner. (Courtesy of Kwasniewski Photographs, UWM Libraries, kw000099.)

Shopping for Polish foods became a bit easier on the Old South Side in 1992, when A&J Polish Deli opened near the corner of Twelfth Street and Lincoln Avenue. The owners were a later Polish immigrant family, the Zbaks. Visitors are welcomed in Polish here, as they would have been 100 years ago. (Courtesy of Urban Anthropology.)

During the earlier Polish era, Swientek's Lingerie and Children's Wear was a popular boutique for family clothing on the Old South Side. Lingerie "musts" in the 1930s included full-length corsets and slips, girdles, and garters. Before department stores became popular, communities were able to purchase these necessities in their own neighborhoods. (Courtesy of Kwasniewski Photographs, UWM Libraries, kw000922.)

Western clothing is seen everywhere on the Old South Side in the 21st century. Spanish (as well as English) is routinely spoken at Durango Western Wear at Eleventh Street and Lincoln Avenue. Opened in 2004 by the Vargas family, this busy boutique specializes in men's, women's, and children's apparel, as well as shoes and boots of the American Southwest. (Courtesy of Urban Anthropology.)

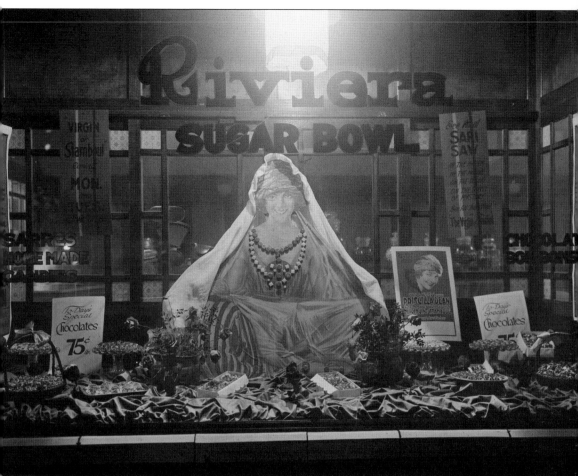

The Riviera Sugar Bowl was located next to the Riviera Theater on Lincoln Avenue. Its decorative window displays and colorful interiors boasted the diverse array of sweets and snacks for sale. Candy that was popular in the 1920s and 1930s included unfamiliar treats such as Chick-O-Sticks, Slo Pokes, and Teaberry Chewing Gum. But it also included familiar names such as Baby Ruth candy bars, Milk Duds, and Reese's Peanut Butter Cups. Theatergoers would often stop at the Sugar Bowl for treats to take with them to the movies. This was long before theaters installed candy stands and popcorn as their principal profit centers. Many owners of the movie palaces were reluctant to build concession stands, for fear of looking like burlesque houses. This began to change during the Great Depression when some palace owners needed new sources of revenue. (Courtesy of Kwasniewski Photographs, UWM Libraries, kw000658.)

By the 21st century, the most popular candy store on the Old South Side was Dulceria la Mexicana. Opened by Jose Jaimes in 2009, this confectionery is housed in the old Lincoln Theater building near Eleventh Street and Lincoln Avenue. A stage, which once enclosed the movie screen, is still sometimes used for community performances. The store specializes in Mexican sweets and piñatas in the usual characters of Spiderman, Thomas the Train, Cars, Minnie Mouse, Dora, princesses, and Tinkerbell. Besides serving children's birthday and communion parties, the candy is also used for *Las Posadas*, an observance that begins on December 16 and ends on Christmas Eve. Each night, groups will go from home to home in the neighborhood, singing a song and expecting the ritualistic refusal of lodging that Joseph and Mary faced. The festivities end with children breaking piñatas. (Courtesy of Urban Anthropology.)

Women's appearance was just as important in the early 20th century as it is today. Above, Tessner's Millinery and Beauty Shoppe on Lincoln Avenue is shown in 1929. The shop specialized in hairdos, cosmetics, and head coverings. The cloche hat was in style (as seen on the woman in the foreground wearing a coat). Cloche hats had a bell shape with bulbous crowns and were pulled down to eye level. Below, an advertising cart is parked in front of Harriet Beauty Shoppe on Lincoln Avenue in 1926. (Both, courtesy of Kwasniewski Photographs, UWM Libraries, kwr001306 (above) and kw000097 (below).)

Meche Vargas, who was born in Mexico, opened Diva's Hair Salon (left) in 2003 across from the Basilica of St. Josaphat. The salon provides haircuts, coloring, styling, spa services, and something a bit out of the ordinary. After hours, local residents gather in the basement of the salon for zumba (a mix of Latin dance and aerobics) classes. Another beauty shop, located on Lincoln and Windlake Avenues, is the Paul Mitchell Salon. Terry Byrd Sierra, owner, originally set up shop on Sixth Street but moved the salon to its current location in 2002. (Both, courtesy of Urban Anthropology.)

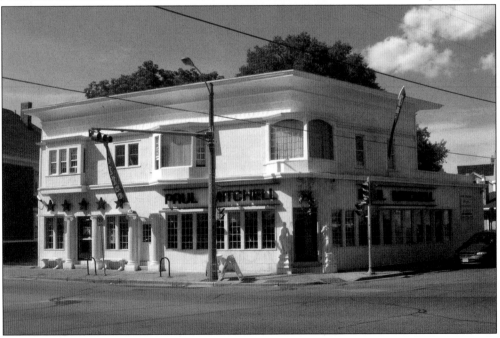

Roman Kwasniewski, the Old South Side's most prolific photographer, purchased a building near what is today Eleventh Street and Lincoln Avenue in the early 20th century (pictured about 1920). The street level of the building became his business, Park Studio, and the upper floors were his family's residence. (Courtesy of Kwasniewski Photographs, UWM Libraries, kw000038.)

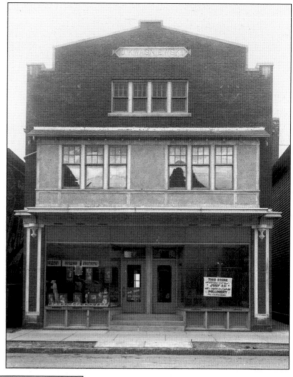

Nelson & Associates was established in the Kwasniewski building in 1980 and closed when the Nelsons retired in 2008. During their years in operation, Nelson & Associates did commercial and industrial photography, digital illustration and retouching, and large format digital printing. Barbara Nelson always referred to the old Kwasniewski building as her family's "Polish castle." (Courtesy of Urban Anthropology.)

A popular restaurant on the Old South Side was Ben Szmanda's Café. One of the restaurant's specialties was oysters. According to tradition, oyster dishes were introduced to the Poles in the 1600s by French Duchess Marie Louise Gonzaga, who married two Polish kings, Wladyslaw IV and John II Casimer. This photograph was taken in 1929, at the start of the Great Depression. (Courtesy of Kwasniewski Photographs, UWM Libraries, kw000924.)

During the Great Depression, many Polish residents dined at Ramona's Café, just beyond the southern border of the Old South Side, on Thirteenth Street. The exterior of the building was photographed on New Year's Eve, 1936. Ramona's featured "American food" and daily specials. (Courtesy of Kwasniewski Photographs, UWM Libraries, kw000924.)

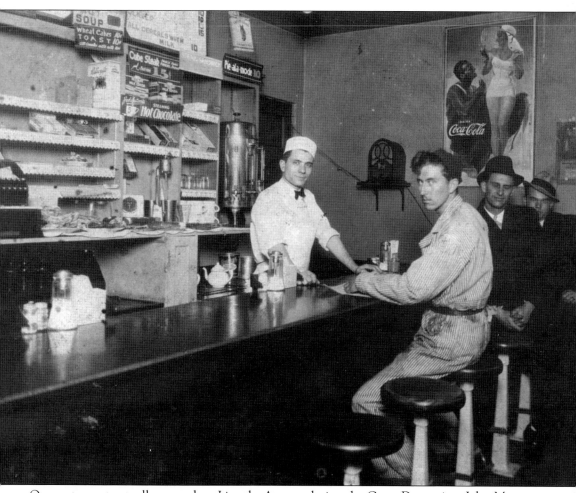

One restaurant actually opened on Lincoln Avenue during the Great Depression. John Mazo, pictured behind the counter, opened Mazo's Burgers on Fourteenth Street and Lincoln Avenue in 1934. Sometimes called "hash houses," restaurants like Mazo's were common in the 1930s and specialized in low-cost spaghetti, beans and wieners, or chili. A typical lunch box might include a mashed bean sandwich and maybe an apple. Soup kitchens were frequented by many on the Old South Side. Mazo's particularly large burgers were 5¢ each, at a time when most restaurants were charging 15¢ to 20¢. Not surprisingly, business prospered. Although the restaurant moved farther south to Twenty-seventh Street and Oklahoma Avenue in the late 1940s, where it remains today, the burgers are still rated among the best in Milwaukee by food critics. (Courtesy of the Mazo family.)

Another Eastern European restaurant thrived as the neighborhood transitioned from Polish to multicultural. Old Town Serbian Gourmet House has continued at its current location at Fifth Place and Lincoln Avenue from 1970 into the 21st century. Still a family enterprise, the restaurant specializes in Balkan and Eastern Mediterranean dishes including *cevapcici*, *burek*, and *sarma*. (Courtesy of Urban Anthropology.)

By 2010, the Old South Side hosted over 15 Mexican restaurants. One example is Club Tres Hermanos at the corner of Windlake and Lincoln Avenues. The restaurant was established by the Orozco brothers in 2002 and serves traditional Mexican dishes. The restaurant expanded and built an outdoor patio in 2008. (Courtesy of Urban Anthropology.)

The Old South Side also opened a restaurant serving rarely seen cuisine from Peru. El Tondero was opened in 1996 by the Caceda family on Thirteenth Street and continued into the 21st century, offering Peruvian specialties such as seafood soup, ceviche, quinoa dishes, flan, beet salads, and meat stews. (Courtesy of Urban Anthropology.)

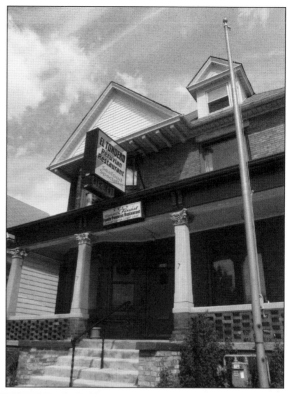

El Salvador opened in 2003 at the site of the old Polish restaurant Polonez on Sixth Street, across from the Basilica of St. Josaphat. Founded by the Arias family, the establishment features Central American specialties such as *pupusas* (stuffed corn pancakes), *horchata* (sweetened rice milk) and tamales (*masa* wrapped in leaf), as well as a few traditional Mexican entrees. (Courtesy of Urban Anthropology.)

INDEX

Ace Boxing Club, 17, 38, 39, 91

Baran Park, 42, 76

Basilica of St. Josaphat, 22, 32, 39, 50, 51, 54, 55–57, 76, 83, 99, 108, 120, 125

Forest Home Cemetery, 78, 79

Holy Name of Jesus, 58

Iglesia Bautista Hispana, 59

Kosciuszko Community Center, 69

Kosciuszko Park, 10, 14–18, 20–22, 28, 29, 30, 33, 38, 40–42, 49, 52, 69, 70, 74, 75, 81, 85, 87, 88, 112

Kosciuszko School, 13, 27, 61

Lincoln Field Park, 78

Modrzejewski Park, 77

Old South Side Settlement Museum, 68, 69, 95

Pulaski Park, 42, 77, 86

St. Adalbert's Church, 45, 58

St. Hyacinth, 19, 54

St. Hyacinth School, 16, 60, 61

St. Josaphat Parish School, 59

St. Stanislaus Church, 28

United Methodist Church (American Indian), 59

ABOUT
URBAN ANTHROPOLOGY

The authors are anthropologists and the principal investigator and executive director of Urban Anthropology Inc. (UrbAn). UrbAn is a nonprofit organization dedicated to the celebration of cultural diversity, problem solving in urban areas, and the expression of both in creative media. For nearly a decade, Urban Anthropology sought a base in a culturally diverse Milwaukee neighborhood in order to establish a settlement museum and develop cultural programming. After conducting oral histories in seven Milwaukee neighborhoods, Urban Anthropology chose the area known locally as the Old South Side for its home.

The Old South Side Settlement Museum opened in 2006, and by 2008 Urban Anthropology had become the neighborhood association for the Baran Park and Lincoln Village neighborhoods that covered most of the Old South Side. During the following years, the organization developed 21 local programs and either photographed or collected over 1,000 images of life on the Old South Side, many of which appear in this volume.

DISCOVER THOUSANDS OF LOCAL HISTORY BOOKS
FEATURING MILLIONS OF VINTAGE IMAGES

Arcadia Publishing, the leading local history publisher in the United States, is committed to making history accessible and meaningful through publishing books that celebrate and preserve the heritage of America's people and places.

Find more books like this at
www.arcadiapublishing.com

Search for your hometown history, your old stomping grounds, and even your favorite sports team.

Consistent with our mission to preserve history on a local level, this book was printed in South Carolina on American-made paper and manufactured entirely in the United States. Products carrying the accredited Forest Stewardship Council (FSC) label are printed on 100 percent FSC-certified paper.

MADE IN THE USA